T0145808

Laurus Nobilis

Laurus Nobilis

Chapters on Art and Life

Vernon Lee

MINT EDITIONS

Laurus Nobilis: Chapters on Art and Life was first published in 1909.

This edition published by Mint Editions 2021.

ISBN 9781513295688 | E-ISBN 9781513297187

Published by Mint Editions®

MINT
EDITIONS

minteditionbooks.com

Publishing Director: Jennifer Newens
Design & Production: Rachel Lopez Metzger
Project Manager: Micaela Clark
Typesetting: Westchester Publishing Services

Contents

The Use of Beauty

I

One afternoon, in Rome, on the way back from the Aventine, the road-mender climbed onto the tram as it trotted slowly along, and fastened to its front, alongside of the place of the driver, a bough of budding bay.

Might one not search long for a better symbol of what we may all do by our life? Bleakness, wind, squalid streets, a car full of heterogeneous people, some very dull, most very common; a laborious jog-trot all the way. But to redeem it all with the pleasantness of beauty and the charm of significance, this laurel branch.

II

Our language does not possess any single word wherewith to sum up the various categories of things (made by nature or made by man, intended solely for the purpose of subserving by mere coincidence) which minister to our organic and many-sided æsthetic instincts: the things affecting us in that absolutely special, unmistakable, and hitherto mysterious manner expressed in our finding them *beautiful*. It is of the part which such things—whether actually present or merely shadowed in our mind—can play in our life; and of the influence of the instinct for beauty on the other instincts making up our nature, that I would treat in these pages. And for this reason I have been glad to accept from the hands of chance, and of that road-mender of the tram-way, the bay laurel as a symbol of what we have no word to express: the aggregate of all art, all poetry, and particularly of all poetic and artistic vision and emotion.

For the Bay Laurel—*Laurus Nobilis* of botanists—happens to be not merely the evergreen, unfading plant into which Apollo metamorphosed, while pursuing, the maiden whom he loved, even as the poet, the artist turns into immortal shapes his own quite personal and transient moods, or as the fairest realities, nobly sought, are transformed, made evergreen and restoratively fragrant for all time in our memory and fancy. It is a plant of noblest utility, averting, as the ancients thought, lightning from the dwellings it surrounded, even as disinterested love for beauty averts

from our minds the dangers which fall on the vain and the covetous; and curing many aches and fevers, even as the contemplation of beauty refreshes and invigorates our spirit. Indeed, we seem to be reading a description no longer of the virtues of the bay laurel, but of the *virtues* of all beautiful sights and sounds, of all beautiful thoughts and emotions, in reading the following quaint and charming words of an old herbal:—

> "The bay leaves are of as necessary use as any other in garden or orchard, for they serve both for pleasure and profit, both for ornament and use, both for honest civil uses and for physic; yea, both for the sick and for the sound, both for the living and for the dead. The bay serveth to adorn the house of God as well as of man, to procure warmth, comfort, and strength to the limbs of men and women; . . . to season vessels wherein are preserved our meats as well as our drinks; to crown or encircle as a garland the heads of the living, and to stick and deck forth the bodies of the dead; so that, from the cradle to the grave we have still use of it, we have still need of it."

III

BEFORE BEGINNING TO EXPOUND THE virtues of Beauty, let me, however, insist that these all depend upon the simple and mysterious fact that—well, that the Beautiful *is* the Beautiful. In our discussion of what the Bay Laurel symbolises, let us keep clear in our memory the lovely shape of the sacred tree, and the noble places in which we have seen it.

There are bay twigs, gathered together in bronze sheaves, in the great garland surrounding Ghiberti's Gates of Paradise. There are two interlaced branches of bay, crisp-edged and slender, carved in fine low relief inside the marble chariot in the Vatican. There is a fan-shaped growth of Apollo's Laurel behind that Venetian portrait of a poet, which was formerly called Ariosto by Titian. And, most suggestive of all, there are the Mycenaean bay leaves of beaten gold, so incredibly thin one might imagine them to be the withered crown of a nameless singer in a forgotten tongue, grown brittle through three thousand years and more.

Each of such presentments, embodying with loving skill some feature of the plant, enhances by association the charm of its reality, accompanying the delight of real bay-trees and bay leaves with

inextricable harmonics, vague recollections of the delight of bronze, of delicately cut marble, of marvellously beaten gold, of deep Venetian crimson and black and auburn.

But best of all, most satisfying and significant, is the remembrance of the bay-trees themselves. They greatly affect the troughs of watercourses, among whose rocks and embanked masonry they love to strike their roots. In such a stream trough, on a spur of the Hill of Fiesole, grow the most beautiful poet's laurels I can think of. The place is one of those hollowings out of a hillside which, revealing how high they lie only by the sky-lines of distant hills, always feel so pleasantly remote. And the peace and austerity of this little valley are heightened by the dove-cot of a farm invisible in the olive-yards, and looking like a hermitage's belfry. The olives are scant and wan in the fields all round, with here and there the blossom of an almond; the oak woods, of faint wintry copper-rose, encroach above; and in the grassy space lying open to the sky, the mountain brook is dyked into a weir, whence the crystalline white water leaps into a chain of shady pools. And there, on the brink of that weir, and all along that stream's shallow upper course among grass and brakes of reeds, are the bay-trees I speak of: groups of three or four at intervals, each a sheaf of smooth tapering boles, tufted high up with evergreen leaves, sparse bunches whose outermost leaves are sharply printed like lance-heads against the sky. Most modest little trees, with their scant berries and rare pale buds; not trees at all, I fancy some people saying. Yet of more consequence, somehow, in their calm disregard of wind, their cheerful, resolute soaring, than any other trees for miles; masters of that little valley, of its rocks, pools, and overhanging foliage; sovereign brothers and rustic demi-gods for whom the violets scent the air among the withered grass in March, and, in May, the nightingales sing through the quivering star night.

Of all southern trees, most simple and aspiring; and certainly most perfect among evergreens, with their straight, faintly carmined shoots, their pliable strong leaves so subtly rippled at the edge, and their clean, dry fragrance; delicate, austere, alert, serene; such are the bay-trees of Apollo.

IV

I HAVE GLADLY ACCEPTED, FROM the hands of that tram-way road-mender, the Bay Laurel—*Laurus Nobilis*—for a symbol of all art, all

poetry, and all poetic and artistic vision and emotion. It has summed up, better than words could do, what the old Herbals call the *virtues*, of all beautiful things and beautiful thoughts. And it has suggested, I hope, the contents of the following notes; the nature of my attempt to trace the influence which art should have on life.

V

BEAUTY, SAVE BY A METAPHORICAL application of the word, is not in the least the same thing as Goodness, any more than beauty (despite Keats' famous assertion) is the same thing as Truth. These three objects of the soul's pursuit have different natures, different laws, and fundamentally different origins. But the energies which express themselves in their pursuit—energies vital, primordial, and necessary even to man's physical survival—have all been evolved under the same stress of adaptation of the human creature to its surroundings; and have therefore, in their beginnings and in their ceaseless growth, been working perpetually in concert, meeting, crossing, and strengthening one another, until they have become indissolubly woven together by a number of great and organic coincidences.

It is these coincidences which all higher philosophy, from Plato downwards, has strained for ever to expound. It is these coincidences, which all religion and all poetry have taken for granted. And to three of these it is that I desire to call attention, persuaded as I am that the scientific progress of our day will make short work of all the spurious æstheticism and all the shortsighted utilitarianism which have cast doubts upon the intimate and vital connection between beauty and every other noble object of our living.

The three coincidences I have chosen are: that between development of the æsthetic faculties and the development of the altruistic instincts; that between development of a sense of æsthetic harmony and a sense of the higher harmonies of universal life; and, before everything else, the coincidence between the preference for æsthetic pleasures and the nobler growth of the individual.

VI

THE PARTICULAR EMOTION PRODUCED IN us by such things as are beautiful, works of art or of nature, recollections and thoughts as well as

sights and sounds, the emotion of æsthetic pleasure, has been recognised ever since the beginning of time as of a mysteriously ennobling quality. All philosophers have told us that; and the religious instinct of all mankind has practically proclaimed it, by employing for the worship of the highest powers, nay, by employing for the mere designation of the godhead, beautiful sights, and sounds, and words by which beautiful sights and sounds are suggested. Nay, there has always lurked in men's minds, and expressed itself in the metaphors of men's speech, an intuition that the Beautiful is in some manner one of the primordial and, so to speak, cosmic powers of the world. The theories of various schools of mental science, and the practice of various schools of art, the practice particularly of the persons styled by themselves æsthetes and by others decadents, have indeed attempted to reduce man's relations with the great world-power Beauty to mere intellectual dilettantism or sensual superfineness. But the general intuition has not been shaken, the intuition which recognised in Beauty a superhuman, and, in that sense, a truly divine power. And now it must become evident that the methods of modern psychology, of the great new science of body and soul, are beginning to explain the reasonableness of this intuition, or, at all events, to show very plainly in what direction we must look for the explanation of it. This much can already be asserted, and can be indicated even to those least versed in recent psychological study, to wit, that the power of Beauty, the essential power therefore of art, is due to the relations of certain visible and audible forms with the chief mental and vital functions of all human beings; relations established throughout the whole process of human and, perhaps, even of animal, evolution; relations seated in the depths of our activities, but radiating upwards even like our vague, organic sense of comfort and discomfort; and permeating, even like our obscure relations with atmospheric conditions, into our highest and clearest consciousness, colouring and altering the whole groundwork of our thoughts and feelings.

Such is the primordial, and, in a sense, the cosmic power of the Beautiful; a power whose very growth, whose constantly more complex nature proclaims its necessary and beneficial action in human evolution. It is the power of making human beings live, for the moment, in a more organically vigorous and harmonious fashion, as mountain air or sea-wind makes them live; but with the difference that it is not merely the bodily, but very essentially the spiritual life, the life of thought and emotion, which is thus raised to unusual harmony and vigour. I may

illustrate this matter by a very individual instance, which will bring to the memory of each of my readers the vivifying power of some beautiful sight or sound or beautiful description. I was seated working by my window, depressed by the London outlook of narrow grey sky, endless grey roofs, and rusty elm tops, when I became conscious of a certain increase of vitality, almost as if I had drunk a glass of wine, because a band somewhere outside had begun to play. After various indifferent pieces, it began a tune, by Handel or in Handel's style, of which I have never known the name, calling it for myself the *Te Deum* Tune. And then it seemed as if my soul, and according to the sensations, in a certain degree my body even, were caught up on those notes, and were striking out as if swimming in a great breezy sea; or as if it had put forth wings and risen into a great free space of air. And, noticing my feelings, I seemed to be conscious that those notes were being played *on me*, my fibres becoming the strings; so that as the notes moved and soared and swelled and radiated like stars and suns, I also, being identified with the sound, having become apparently the sound itself, must needs move and soar with them.

We can all recollect a dozen instances when architecture, music, painting, or some sudden sight of sea or mountain, have thus affected us; and all poetry, particularly all great lyric poetry, Goethe's, Shelley's, Wordsworth's, and, above all, Browning's, is full of the record of such experience.

I have said that the difference between this æsthetic heightening of our vitality (and this that I have been describing is, I pray you to observe, the æsthetic phenomenon *par excellence*), and such other heightening of vitality as we experience from going into fresh air and sunshine or taking fortifying food, the difference between the æsthetic and the mere physiological pleasurable excitement consists herein, that in the case of beauty, it is not merely our physical but our spiritual life which is suddenly rendered more vigorous. We do not merely breathe better and digest better, though that is no small gain, but we seem to understand better. Under the vitalising touch of the Beautiful, our consciousness seems filled with the affirmation of what life is, what is worth being, what among our many thoughts and acts and feelings are real and organic and important, what among the many possible moods is the real, eternal *ourself*.

Such are the great forces of Nature gathered up in what we call the *æsthetic phenomenon*, and it is these forces of Nature which, stolen

from heaven by the man of genius or the nation of genius, and welded together in music, or architecture, in the arts of visible design or of written thoughts, give to the great work of art its power to quicken the life of our soul.

VII

I HOPE I HAVE BEEN able to indicate how, by its essential nature, by the primordial power it embodies, all Beauty, and particularly Beauty in art, tends to fortify and refine the spiritual life of the individual.

But this is only half of the question, for, in order to get the full benefit of beautiful things and beautiful thoughts, to obtain in the highest potency those potent æsthetic emotions, the individual must undergo a course of self-training, of self-initiation, which in its turn elicits and improves some of the highest qualities of his soul. Nay, as every great writer on art has felt, from Plato to Ruskin, but none has expressed as clearly as Mr. Pater, in all true æsthetic training there must needs enter an ethical element, almost an ascetic one.

The greatest art bestows pleasure just in proportion as people are capable of buying that pleasure at the price of attention, intelligence, and reverent sympathy. For great art is such as is richly endowed, full of variety, subtlety, and suggestiveness; full of delightfulness enough for a lifetime, the lifetime of generations and generations of men; great art is to its true lovers like Cleopatra to Antony—"age cannot wither it, nor custom stale its infinite variety." Indeed, when it is the greatest art of all, the art produced by the marvellous artist, the most gifted race, and the longest centuries, we find ourselves in presence of something which, like Nature itself, contains more beauty, suggests more thought, works more miracles than anyone of us has faculties to appreciate fully. So that, in some of Titian's pictures and Michael Angelo's frescoes, the great Greek sculptures, certain cantos of Dante and plays of Shakespeare, fugues of Bach, scenes of Mozart and quartets of Beethoven, we can each of us, looking our closest, feeling our uttermost, see and feel perhaps but a trifling portion of what there is to be seen and felt, leaving other sides, other perfections, to be appreciated by our neighbours. Till it comes to pass that we find different persons very differently delighted by the same masterpiece, and accounting most discrepantly for their delight in it.

Now such pleasure as this requires not merely a vast amount of activity on our part, since all pleasure, even the lowest, is the expression

of an activity; it requires a vast amount of attention, of intelligence, of what, in races or in individuals, means special training.

VIII

THERE IS A SAD CONFUSION in men's minds on the very essential subject of pleasure. We tend, most of us, to oppose the idea of pleasure to the idea of work, effort, strenuousness, patience; and, therefore, recognise as pleasures only those which cost none of these things, or as little as possible; pleasures which, instead of being produced through our will and act, impose themselves upon us from outside. In all art— for art stands halfway between the sensual and emotional experiences and the experiences of the mere reasoning intellect—in all art there is necessarily an element which thus imposes itself upon us from without, an element which takes and catches us: colour, strangeness of outline, sentimental or terrible quality, rhythm exciting the muscles, or clang which tickles the ear. But the art which thus takes and catches our attention the most easily, asking nothing in return, or next to nothing, is also the poorest art: the oleograph, the pretty woman in the fashion plate, the caricature, the representation of some domestic or harrowing scene, children being put to bed, babes in the wood, railway accidents, etc.; or again, dance or march music, and the equivalents of all this in verse. It catches your attention, instead of your attention conquering it; but it speedily ceases to interest, gives you nothing more, cloys, or comes to a dead stop. It resembles thus far mere sensual pleasure, a savoury dish, a glass of good wine, an excellent cigar, a warm bed, which impose themselves on the nerves without expenditure of attention; with the result, of course, that little or nothing remains, a sensual impression dying, so to speak, childless, a barren, disconnected thing, without place in the memory, unmarried as it is to the memory's clients, thought and human feeling.

If so many people prefer poor art to great, 'tis because they refuse to give, through inability or unwillingness, as much of their soul as great art requires for its enjoyment. And it is noticeable that busy men, coming to art for pleasure when they are too weary for looking, listening, or thinking, so often prefer the sensation-novel, the music-hall song, and such painting as is but a costlier kind of oleograph; treating all other art as humbug, and art in general as a trifle wherewith to wile away a lazy moment, a trifle about which every man *can know what he likes best*.

Thus it is that great art makes, by coincidence, the same demands as noble thinking and acting. For, even as all noble sports develop muscle, develop eye, skill, quickness and pluck in bodily movement, qualities which are valuable also in the practical business of life; so also the appreciation of noble kinds of art implies the acquisition of habits of accuracy, of patience, of respectfulness, and suspension of judgment, of preference of future good over present, of harmony and clearness, of sympathy (when we come to literary art), judgment and kindly fairness, which are all of them useful to our neighbours and ourselves in the many contingencies and obscurities of real life. Now this is not so with the pleasures of the senses: the pleasures of the senses do not increase by sharing, and sometimes cannot be shared at all; they are, moreover, evanescent, leaving us no richer; above all, they cultivate in ourselves qualities useful only for that particular enjoyment. Thus, a highly discriminating palate may have saved the life of animals and savages, but what can its subtleness do nowadays beyond making us into gormandisers and winebibbers, or, at best, into cooks and tasters for the service of gormandising and winebibbing persons?

IX

DELIGHT IN BEAUTIFUL THINGS AND in beautiful thoughts requires, therefore, a considerable exercise of the will and the attention, such as is not demanded by our lower enjoyments. Indeed, it is probably this absence of moral and intellectual effort which recommends such lower kinds of pleasure to a large number of persons. I have said lower *kinds* of pleasure, because there are other enjoyments besides those of the senses which entail no moral improvement in ourselves: the enjoyments connected with vanity and greed. We should not—even if any of us could be sure of being impeccable on these points—we should not be too hard on the persons and the classes of persons who are conscious of no other kind of enjoyment. They are not necessarily base, not necessarily sensual or vain, because they care only for bodily indulgence, for notice and gain. They are very likely not base, but only apathetic, slothful, or very tired. The noble sport, the intellectual problem, the great work of art, the divinely beautiful effect in Nature, require that one should *give oneself*; the French-cooked dinner as much as the pot of beer; the game of chance, whether with clean cards at a club or with greasy ones in a tap-room; the outdoing of one's neighbours, whether

by the ragged heroes of Zola or the well-groomed heroes of Balzac, require no such coming forward of the soul: they *take* us, without any need for our giving ourselves. Hence, as I have just said, the preference for them does not imply original baseness, but only lack of higher energy. We can judge of the condition of those who can taste no other pleasures by remembering what the best of us are when we are tired or ill: vaguely craving for interests, sensations, emotions, variety, but quite unable to procure them through our own effort, and longing for them to come to us from without. Now, in our still very badly organised world, an enormous number of people are condemned by the tyranny of poverty or the tyranny of fashion, to be, when the day's work or the day's business is done, in just such a condition of fatigue and languor, of craving, therefore, for the baser kinds of pleasure. We all recognise that this is the case with what we call *poor people*, and that this is why poor people are apt to prefer the public-house to the picture gallery or the concert-room. It would be greatly to the purpose were we to acknowledge that it is largely the case with the rich, and that for that reason the rich are apt to take more pleasure in ostentatious display of their properties than in contemplation of such beauty as is accessible to all men. Indeed, it is one of the ironies of the barbarous condition we are pleased to call *civilisation*, that so many rich men—thousands daily—are systematically toiling and moiling till they are unable to enjoy any pleasure which requires vigour of mind and attention, rendering themselves impotent, from sheer fatigue, to enjoy the delights which life gives generously to all those who fervently seek them. And what for? Largely for the sake of those pleasures which can be had only for money, but which can be enjoyed without using one's soul.

X

(Parenthetical)

"AND THESE, YOU SEE," I said, "are bay-trees, the laurels they used the leaves of to. . ."

I was going to say "to crown poets," but I left my sentence in mid-air, because of course he knew that as well as I.

"Precisely," he answered with intelligent interest—"I have noticed that the leaves are sometimes put in sardine boxes."

Soon after this conversation I discovered the curious circumstance that one of the greatest of peoples and perhaps the most favoured by Apollo, calls Laurus Nobilis "Laurier-Sauce." The name is French; the symbol, alas, of universal application.

This paragraph X had been intended to deal with "Art as it is understood by persons of fashion and eminent men of business."

XI

Thus it is that real æsthetic keenness—and æsthetic keenness, as I shall show you in my next chapter, means appreciating beauty, not collecting beautiful properties—thus it is that all æsthetic keenness implies a development of the qualities of patience, attention, reverence, and of that vigour of soul which is not called forth, but rather impaired, by the coarser enjoyments of the senses and of vanity. So far, therefore, we have seen that the capacity for æsthetic pleasure is allied to a certain nobility in the individual. I think I can show that the preference for æsthetic pleasure tends also to a happier relation between the individual and his fellows.

But the cultivation of our æsthetic pleasures does not merely necessitate our improvement in certain very essential moral qualities. It implies as much, in a way, as the cultivation of the intellect and the sympathies, that we should live chiefly in the spirit, in which alone, as philosophers and mystics have rightly understood, there is safety from the worst miseries and room for the most complete happiness. Only, we shall learn from the study of our æsthetic pleasures that while the stoics and mystics have been right in affirming that the spirit only can give the highest good, they have been fatally wrong in the reason they gave for their preference. And we may learn from our æsthetic experiences that the spirit is useful, not in detaching us from the enjoyable things of life, but, on the contrary, in giving us their consummate possession. The spirit—one of whose most precious capacities is that it enables us to print off all outside things on to ourselves, to store moods and emotions, to recombine and reinforce past impressions into present ones—the spirit puts pleasure more into our own keeping, making it more independent of time and place, of circumstances, and, what is equally important, independent of other people's strivings after pleasure, by which our own, while they clash and hamper, are so often impeded.

XII

FOR OUR INTIMATE COMMERCE WITH beautiful things and beautiful thoughts does not exist only, or even chiefly, at the moment of seeing, or hearing, or reading; nay, if the beautiful touched us only at such separate and special moments, the beautiful would play but an insignificant part in our existence.

As a fact, those moments represent very often only the act of *storage*, or not much more. Our real æsthetic life is in ourselves, often isolated from the beautiful words, objects, or sounds; sometimes almost unconscious; permeating the whole rest of life in certain highly æsthetic individuals, and, however mixed with other activities, as constant as the life of the intellect and sympathies; nay, as constant as the life of assimilation and motion. We can live off a beautiful object, we can live by its means, even when its visible or audible image is partially, nay, sometimes wholly, obliterated; for the emotional condition can survive the image and be awakened at the mere name, awakened sufficiently to heighten the emotion caused by other images of beauty. We can sometimes feel, so to speak, the spiritual companionship and comfort of a work of art, or of a scene in nature, nay, almost its particular caress to our whole being, when the work of art or the scene has grown faint in our memory, but the emotion it awakened has kept warm.

Now this possibility of storing for later use, of increasing by combination, the impressions of beautiful things, makes art—and by art I mean all æsthetic activity, whether in the professed artist who creates or the unconscious artist who assimilates—the type of such pleasures as are within our own keeping, and makes the æsthetic life typical also of that life of the spirit in which alone we can realise any kind of human freedom. We shall all of us meet with examples thereof if we seek through our consciousness. That such things existed was made clear to me during a weary period of illness, for which I shall always be grateful, since it taught me, in those months of incapacity for enjoyment, that there is a safe kind of pleasure, *the pleasure we can defer*. I spent part of that time at Tangier, surrounded by everything which could delight me, and in none of which I took any real delight. I did not enjoy Tangier at the time, but I have enjoyed Tangier ever since, on the principle of the bee eating its honey months after making it. The reality of Tangier, I mean the reality of my presence there, and the state of my nerves, were not in the relation of enjoyment. But how often has

not the image of Tangier, the remembrance of what I saw and did there, returned and haunted me in the most enjoyable fashion.

After all, is it not often the case with pictures, statues, journeys, and the reading of books? The weariness entailed, the mere continuity of looking or attending, quite apart from tiresome accompanying circumstances, make the apparently real act, what we expect to be the act of enjoyment, quite illusory; like Coleridge, "we see, not *feel*, how beautiful things are." Later on, all odious accompanying circumstances are utterly forgotten, eliminated, and the weariness is gone: we enjoy not merely unhampered by accidents, but in the very way our heart desires. For we can choose—our mood unconsciously does it for us—the right moment and right accessories for consuming some of our stored delights; moreover, we can add what condiments and make what mixtures suit us best at that moment. We draw not merely upon one past reality, making its essentials present, but upon dozens. To revert to Tangier (whose experience first brought these possibilities clearly before me), I find I enjoy it in connection with Venice, the mixture having a special roundness of tone or flavour. Similarly, I once heard Bach's *Magnificat*, with St. Mark's of Venice as a background in my imagination. Again, certain moonlight songs of Schumann have blended wonderfully with remembrances of old Italian villas. King Solomon, in all his ships, could not have carried the things which I can draw, in less than a second, from one tiny convolution of my brain, from one corner of my mind. No wizard that ever lived had spells which could evoke such kingdoms and worlds as anyone of us can conjure up with certain words: Greece, the Middle Ages, Orpheus, Robin Hood, Mary Stuart, Ancient Rome, the Far East.

XIII

AND HERE, AS FIT ILLUSTRATION of these beneficent powers, which can free us from a life where we stifle and raise us into a life where we can breathe and grow, let me record my gratitude to a certain young goat, which, on one occasion, turned what might have been a detestable hour into a pleasant one.

The goat, or rather kid, a charming gazelle-like creature, with budding horns and broad, hard forehead, was one of my fourteen fellow passengers in a third-class carriage on a certain bank holiday Saturday. Riding and standing in such crowded misery had cast a general gloom

over all the holiday makers; they seemed to have forgotten the coming outing in sullen hatred of all their neighbours; and I confess that I too began to wonder whether Bank Holiday was an altogether delightful institution. But the goat had no such doubts. Leaning against the boy who was taking it holiday-making, it tried very gently to climb and butt, and to play with its sulky fellow travellers. And as it did so it seemed to radiate a sort of poetry on everything: vague impressions of rocks, woods, hedges, the Alps, Italy, and Greece; mythology, of course, and that amusement of "jouer avec des chèvres apprivoisées," which that great charmer M. Renan has attributed to his charming Greek people. Now, as I realised the joy of the goat on finding itself among the beech woods and short grass of the Hertfordshire hills, I began also to see my other fellow travellers no longer as surly people resenting each other's presence, but as happy human beings admitted once more to the pleasant things of life. The goat had quite put me in conceit with bank holiday. When it got out of the train at Berkhampstead, the emptier carriage seemed suddenly more crowded, and my fellow travellers more discontented. But I remained quite pleased, and when I had alighted, found that instead of a horrible journey, I could remember only a rather exquisite little adventure. That beneficent goat had acted as Pegasus; and on its small back my spirit had ridden to the places it loves.

In this fashion does the true æsthete tend to prefer, even like the austerest moralist, the delights which, being of the spirit, are most independent of circumstances and most in the individual's own keeping.

XIV

IT WAS MR. PATER WHO FIRST pointed out how the habit of æsthetic enjoyment makes the epicurean into an ascetic. He builds as little as possible on the things of the senses and the moment, knowing how little, in comparison, we have either in our power. For, even if the desired object, person, or circumstance comes, how often does it not come at the wrong hour! In this world, which mankind fits still so badly, the wish and its fulfilling are rarely in unison, rarely in harmony, but follow each other, most often, like vibrations of different instruments, at intervals which can only jar. The *n'est-ce que cela*, the inability to enjoy, of successful ambition and favoured, passionate love, is famous; and short of love even and ambition, we all know the flatness of long-desired pleasures. King Solomon, who had not been enough of an ascetic, as

we all know, and therefore ended off in cynicism, knew that there is not only satiety as a result of enjoyment; but a sort of satiety also, an absence of keenness, an incapacity for caring, due to the deferring of enjoyment. He doubtless knew, among other items of vanity, that our wishes are often fulfilled without our even knowing it, so indifferent have we become through long waiting, or so changed in our wants.

XV

THERE IS ANOTHER REASON FOR such ascetism as was taught in *Marius the Epicurean* and in Pater's book on Plato: the modest certainty of all pleasure derived from the beautiful will accustom the perfect æsthete to seek for the like in other branches of activity. Accustomed to the happiness which is in his own keeping, he will view with suspicion all craving for satisfactions which are beyond his control. He will not ask to be given the moon, and he will not even wish to be given it, lest the wish should grow into a want; he will make the best of candles and glowworms and of distant heavenly luminaries. Moreover, being accustomed to enjoy the mere sight of things as much as other folk do their possession, he will probably actually prefer that the moon should be hanging in the heavens, and not on his staircase.

Again, having experience of the æsthetic pleasures which involve, in what Milton called their sober waking bliss, no wear and tear, no reaction of satiety, he will not care much for the more rapturous pleasures of passion and success, which always cost as much as they are worth. He will be unwilling to run into such debt with his own feelings, having learned from æsthetic pleasure that there are activities of the soul which, instead of impoverishing, enrich it.

Thus does the commerce with beautiful things and beautiful thoughts tend to develop in us that healthy kind of ascetism so requisite to every workable scheme of greater happiness for the individual and the plurality: self-restraint, choice of aims, consistent and thorough-paced subordination of the lesser interest to the greater; above all, what sums up ascetism as an efficacious means towards happiness, preference of the spiritual, the unconditional, the durable, instead of the temporal, the uncertain, and the fleeting.

The intimate and continuous intercourse with the Beautiful teaches us, therefore, the renunciation of the unnecessary for the sake of the possible. It teaches ascetism leading not to indifference and Nervana,

but to higher complexities of vitalisation, to a more complete and harmonious rhythm of individual existence.

XVI

Art can thus train the soul because art is free; or, more strictly speaking, because art is the only complete expression, the only consistent realisation of our freedom. In other parts of our life, business, affection, passion, pursuit of utility, glory or truth, we are for ever *conditioned*. We are twisting perpetually, perpetually stopped short and deflected, picking our way among the visible and barely visible habits, interests, desires, shortcomings, of others and of that portion of ourselves which, in the light of that particular moment and circumstance, seems to be foreign to us, to be another's. We can no more follow the straight line of our wishes than can the passenger in Venice among those labyrinthine streets, whose everlasting, unexpected bends are due to canals which the streets themselves prevent his seeing. Moreover, in those gropings among looming or unseen obstacles, we are pulled hither and thither, checked and misled by the recurring doubt as to which, of these thwarted and yielding selves, may be the chief and real one, and which, of the goals we are never allowed finally to touch, is the goal we spontaneously tend to.

Now it is different in the case of Art, and of all those æsthetic activities, often personal and private, which are connected with Art and may be grouped together under Art's name. Art exists to please, and, when left to ourselves, we feel in what our pleasure lies. Art is a free, most open and visible space, where we disport ourselves freely. Indeed, it has long been remarked (the poet Schiller working out the theory) that, as there is in man's nature a longing for mere unconditioned exercise, one of Art's chief missions is to give us free scope to be ourselves. If therefore Art is the playground where each individual, each nation or each century, not merely toils, but untrammelled by momentary passion, unhampered by outer cares, freely exists and feels itself, then Art may surely become the training-place of our soul. Art may teach us how to employ our liberty, how to select our wishes: employ our liberty so as to respect that of others; select our wishes in such a manner as to further the wishes of our fellow-creatures.

For there are various, and variously good or evil ways of following our instincts, fulfilling our desires, in short, of being independent of

outer circumstances; in other words, there are worthy and worthless ways of using our leisure and our surplus energy, of seeking our pleasure. And Art—Art and all Art here stands for—can train us to do so without injuring others, without wasting the material and spiritual riches of the world. Art can train us to delight in the higher harmonies of existence; train us to open our eyes, ears and souls, instead of shutting them, to the wider modes of universal life.

In such manner, to resume our symbol of the bay laurel which the road-mender stuck on to the front of that tramcar, can our love for the beautiful avert, like the plant of Apollo, many of the storms, and cure many of the fevers, of life.

"Nisi Citharam"

I

IT IS WELL THAT THIS second chapter—in which I propose to show how a genuine æsthetic development tends to render the individual more useful, or at least less harmful, to his fellow-men—should begin, like the first, with a symbol, such as may sum up my meaning, and point it out in the process of my expounding it. The symbol is contained in the saying of the Abbot Joachim of Flora, one of the great precursors of St. Francis, to wit: "He that is a true monk considers nothing his own except a lyre—*nihil reputat esse suum nisi citharam*." Yes; nothing except a lyre.

II

BUT THAT LYRE, OUR ONLY real possession, is our *Soul*. It must be shaped, and strung, and kept carefully in tune; no easy matter in surroundings little suited to delicate instruments and delicate music. Possessing it, we possess, in the only true sense of possession, the whole world. For going along our way, whether rough or even, there are formed within us, singing the beauty and wonder of *what is* or *what should* be, mysterious sequences and harmonies of notes, new every time, answering to the primæval everlasting affinities between ourselves and all things; our souls becoming musical under the touch of the universe.

Let us bear this in mind, this symbol of the lyre which Abbot Joachim allowed as sole property to the man of spiritual life. And let us remember that, as I tried to show in my previous chapter, the true Lover of the Beautiful, active, self-restrained, and indifferent to lower pleasures and interests, is in one sense your man of real spiritual life. For the symbol of Abbot Joachim's lyre will make it easier to follow my meaning, and easier to forestall it, while I try to convince you that art, and all æsthetic activity, is important as a type of the only kind of pleasure which reasonable beings should admit of, the kind of pleasure which tends not to diminish by wastefulness and exclusive appropriation, but to increase by sympathy, the possible pleasures of other persons.

III

'TIS NO EXCESSIVE PURITANISM TO say that while pleasure, in the abstract, is a great, perhaps the greatest, good; pleasures, our actual pleasures in the concrete, are very often evil.

Many of the pleasures which we allow ourselves, and which all the world admits our right to, happen to be such as waste wealth and time, make light of the advantage of others, and of the good of our own souls. This fact does not imply either original sinfulness or degeneracy— religious and scientific terms for the same thing—in poor mankind. It means merely that we are all of us as yet very undeveloped creatures; the majority, moreover, less developed than the minority, and the bulk of each individual's nature very much in the rear of his own aspirations and definitions. Mankind, in the process of adapting itself to external circumstances, has perforce evolved a certain amount of intellectual and moral quality; but that intellectual and moral quality is, so far, merely a means for rendering material existence endurable; it will have to become itself the origin and aim of what we must call a spiritual side of life. In the meanwhile, human beings do not get any large proportion of their enjoyment from what they admit to be their nobler side.

Hence it is that even when you have got rid of the mere struggle for existence—fed, clothed, and housed your civilised savage, and secured food, clothes, and shelter for his brood—you have by no means provided against his destructive, pain-giving activities. He has spare time and energy; and these he will devote, ten to one, to recreations involving, at the best, the slaughter of harmless creatures; at the worst, to the wasting of valuable substance, of what might be other people's food; or else to the hurting of other people's feelings in various games of chance or skill, particularly in the great skilled game of brag called "Society."

Our gentlemanly ancestors, indeed, could not amuse themselves without emptying a certain number of bottles and passing some hours under the table; while our nimble-witted French neighbours, we are told, included in their expenditure on convivial amusements a curious item called *la casse*, to wit, the smashing of plates and glasses. The Spaniards, on the other hand, have bull-fights, most shocking spectacles, as we know, for we make it a point to witness them when we are over there. Undoubtedly we have immensely improved in such matters, but we need a great deal of further improvement. Most people

are safe only when at work, and become mischievous when they begin to play. They do not know how to *kill time* (for that is the way in which we poor mortals regard life) without incidentally killing something else: proximately birds and beasts, and their neighbours' good fame; more remotely, but as surely, the constitution of their descendants, and the possible wages of the working classes.

It is quite marvellous how little aptness there is in the existing human being for taking pleasure either in what already exists ready to hand, or in the making of something which had better be there; in what can be enjoyed without diminishing the enjoyment of others, as nature, books, art, thought, and the better qualities of one's neighbours. In fact, one reason why there is something so morally pleasant in cricket and football and rowing and riding and dancing, is surely that they furnish on the physical plane the counterpart of what is so sadly lacking on the spiritual: amusements which do good to the individual and no harm to his fellows.

Of course, in our state neither of original sinfulness nor of degeneracy, but of very imperfect development, it is still useless and absurd to tell people to make use of intellectual and moral resources which they have not yet got. It is as vain to preach to the majority of the well-to-do the duty of abstinence from wastefulness, rivalry, and ostentation as it is vain to preach to the majority of the badly-off abstinence from alcohol; without such pleasures their life would be unendurably insipid.

But inevitable as is such evil in the present, it inevitably brings its contingent of wretchedness; and it is therefore the business of all such as *could* become the forerunners of a better state of things to refuse to follow the lead of their inferiors. Exactly because the majority is still so hopelessly wasteful and mischievous, does it behove the minority not merely to work to some profit, but to play without damage. To do this should become the mark of Nature's aristocracy, a sign of liberality of spiritual birth and breeding, a question of *noblesse oblige*.

IV

AND HERE COMES IN THE immense importance of Art as a type of pleasure: of Art in the sense of æsthetic appreciation even more than of æsthetic creation; of Art considered as the extracting and combining of beauty in the mind of the obscure layman quite as much as the

embodiment of such extracted and combined beauty in the visible or audible work of the great artist.

For experience of true æsthetic activity must teach us, in proportion as it is genuine and ample, that the enjoyment of the beautiful is not merely independent of, but actually incompatible with, that tendency to buy our satisfaction at the expense of others which remains more or less in all of us as a survival from savagery. The reasons why genuine æsthetic feeling inhibits these obsolescent instincts of rapacity and ruthlessness, are reasons negative and positive, and may be roughly divided into three headings. Only one of them is generally admitted to exist, and of it, therefore, I shall speak very briefly, I mean the fact that the enjoyment of beautiful things is originally and intrinsically one of those which are heightened by sharing. We know it instinctively when, as children, we drag our comrades and elders to the window when a regiment passes or a circus parades by; we learn it more and more as we advance in life, and find that we must get other people to see the pictures, to hear the music, to read the books which we admire. It is a case of what psychologists call the *contagion of emotion*, by which the feeling of one individual is strengthened by the expression of similar feeling in his neighbour, and is explicable, most likely, by the fact that the greatest effort is always required to overcome original inertness, and that two efforts, like two horses starting a carriage instead of one, combined give more than double the value of each taken separately. The fact of this æsthetic sociability is so obvious that we need not discuss it any further, but merely hold it over to add, at last, to the result of the two other reasons, negative and positive, which tend to make æsthetic enjoyment the type of unselfish, nay, even of altruistic pleasure.

V

THE FIRST OF THESE REASONS, the negative one, is that æsthetic pleasure is not in the least dependent upon the fact of personal ownership, and that it therefore affords an opportunity of leaving inactive, of beginning to atrophy by inactivity, the passion for exclusive possession, for individual advantage, which is at the bottom of all bad luxury, of all ostentation, and of nearly all rapacity. But before entering on this discussion I would beg my reader to call to mind that curious saying of Abbot Joachim's; and to consider that I wish to prove that, like his true monk, the true æsthete, who nowadays loves and praises creation

much as the true monk did in former centuries, can really possess as sole personal possession only a musical instrument—to wit, his own well-strung and resonant soul. Having said this, we will proceed to the question of Luxury, by which I mean the possession of such things as minister only to weakness and vanity, of such things as we cannot reasonably hope that all men may some day equally possess.

When we are young—and most of us remain mere withered children, never attaining maturity, in similar matters—we are usually attracted by luxury and luxurious living. We are possessed by that youthful instinct of union, fusion, marriage, so to speak, with what our soul desires; we hanker after close contact and complete possession; and we fancy, in our inexperience, that luxury, the accumulation of valuables, the appropriation of opportunities, the fact of rejecting from our life all that is not costly, brilliant, and dainty, implies such fusion of our soul with beauty.

But, as we reach maturity, we find that this is all delusion. We learn, from the experience of occasions when our soul has truly possessed the beautiful, or been possessed by it, that if such union with the harmony of outer things is rare, perhaps impossible, among squalor and weariness, it is difficult and anomalous in the condition which we entitle luxury.

We learn that our assimilation of beauty, and that momentary renewal of our soul which it effects, rarely arises from our own ownership; but comes, taking us by surprise, in presence of hills, streams, memories of pictures, poets' words, and strains of music, which are not, and cannot be, our property. The essential character of beauty is its being a relation between ourselves and certain objects. The emotion to which we attach its name is produced, motived by something outside us, pictures, music, landscape, or whatever it may be; but the emotion resides in us, and it is the emotion, and not merely its object, which we desire. Hence material possession has no æsthetic meaning. We possess a beautiful object with our soul; the possession thereof with our hands or our legal rights brings us no nearer the beauty. Ownership, in this sense, may empower us to destroy or hide the object and thus cheat others of the possession of its beauty, but does not help *us* to possess that beauty. It is with beauty as with that singer who answered Catherine II, "Your Majesty's policemen can make me *scream*, but they cannot make me *sing*;" and she might have added, for my parallel, "Your policemen, great Empress, even could they make *me* sing, would not be able to make *you* hear."

VI

Hᴇɴᴄᴇ ᴀʟʟ sᴛʀᴏɴɢ ᴀᴇsᴛʜᴇᴛɪᴄ ꜰᴇᴇʟɪɴɢ will always prefer ownership of the mental image to ownership of the tangible object. And any desire for material appropriation or exclusive enjoyment will be merely so much weakening and adulteration of the æsthetic sentiment. Since the mental image, the only thing æsthetically possessed, is in no way diminished or damaged by sharing; nay, we have seen that by one of the most gracious coincidences between beauty and kindliness, the æsthetic emotion is even intensified by the knowledge of co-existence in others: the delight in each person communicating itself, like a musical third, fifth, or octave, to the similar yet different delight in his neighbour, harmonic enriching harmonic by stimulating fresh vibration.

If, then, we wish to possess casts, copies, or photographs of certain works of art, this is, æsthetically considered, exactly as we wish to have the means—railway tickets, permissions for galleries, and so forth—of seeing certain pictures or statues as often as we wish. For we feel that the images in our mind require renewing, or that, in combination with other more recently acquired images, they will, if renewed, yield a new kind of delight. But this is quite another matter from wishing to own the material object, the thing we call *work of art itself*, forgetting that it is a work of art only for the soul capable of instating it as such.

Thus, in every person who truly cares for beauty, there is a necessary tendency to replace the illusory legal act of ownership by the real spiritual act of appreciation. Charles Lamb already expressed this delightfully in the essay on the old manor-house. Compared with his possession of its beauties, its walks, tapestried walls and family portraits, nay, even of the ghosts of former proprietors, the possession by the legal owner was utterly nugatory, unreal:

> "Mine too, Blakesmoor, was thy noble Marble Hall, with its mosaic pavements, and its twelve Cæsars; . . . mine, too, thy lofty Justice Hall, with its one chair of authority. . . Mine, too— whose else?—thy costly fruit-garden. . . thy ampler pleasure-garden. . . thy firry wilderness. . . I was the true descendant of those old W——'s, and not the present family of that name, who had fled the old waste places."

How often have not some of us felt like that; and how much might not those of us who never have, learn, could they learn, from those words of Elia?

VII

I HAVE SPOKEN OF *MATERIAL, actual* possession. But if we look closer at it we shall see that, save with regard to the things which are actually consumed, destroyed, disintegrated, changed to something else in their enjoyment, the notion of ordinary possession is a mere delusion. It can be got only by a constant obtrusion of a mere idea, the *idea of self*, and of such unsatisfactory ideas as one's right, for instance, to exclude others. 'Tis like the tension of a muscle, this constant keeping the consciousness aware by repeating "Mine—mine—*mine* and not *theirs*; not *theirs*, but *mine*." And this wearisome act of self-assertion leaves little power for appreciation, for the appreciation which others can have quite equally, and without which there is no reality at all in ownership.

Hence, the deeper our enjoyment of beauty, the freer shall we become of the dreadful delusion of exclusive appropriation, despising such unreal possession in proportion as we have tasted the real one. We shall know the two kinds of ownership too well apart to let ourselves be cozened into cumbering our lives with material properties and their responsibilities. We shall save up our vigour, not for obtaining and keeping (think of the thousand efforts and cares of ownership, even the most negative) the things which yield happy impressions, but for receiving and storing up and making capital of those impressions. We shall seek to furnish our mind with beautiful thoughts, not our houses with pretty things.

VIII

I HOPE I HAVE MADE clear enough that æsthetic enjoyment is hostile to the unkind and wasteful pleasures of selfish indulgence and selfish appropriation, because the true possession of the beautiful things of Nature, of Art, and of thought is spiritual, and neither damages, nor diminishes, nor hoards them; because the lover of the beautiful seeks for beautiful impressions and remembrances, which are vested in his soul, and not in material objects. That is the negative benefit of the love

of the beautiful. Let us now proceed to the positive and active assistance which it renders, when genuine and thorough-paced, to such thought as we give to the happiness and dignity of others.

IX

I HAVE SAID THAT OUR pleasure in the beautiful is essentially a spiritual phenomenon, one, I mean, which deals with our own perceptions and emotions, altering the contents of our mind, while leaving the beautiful object itself intact and unaltered. This being the case, it is easy to understand that our æsthetic pleasure will be complete and extensive in proportion to the amount of activity of our soul; for, remember, all pleasure is proportionate to activity, and, as I said in my first chapter, great beauty does not merely *take us*, but *we* must give *ourselves to it*. Hence, an increase in the capacity for æsthetic pleasure will mean, *cæteris paribus*, an increase in a portion of our spiritual activity, a greater readiness to take small hints, to connect different items, to reject the lesser good for the greater. Moreover, a great, perhaps the greater, part of our æsthetic pleasure is due, as I also told you before, to the storing of impressions in our mind, and to the combining of them there with other impressions. Indeed, it is for this reason that I have made no difference, save in intensity between æsthetic creation, so called, and æsthetic appreciation; telling you, on the contrary, that the artistic layman creates, produces something new and personal, only in a less degree than the professed artist.

For the æsthetic life does not consist merely in the perception of the beautiful object, not merely in the emotion of that spiritual contact between the beautiful product of art or of nature and the soul of the appreciator: it is continued in the emotions and images and thoughts which are awakened by that perception; and the æsthetic life *is* life, is something continuous and organic, just because new forms, however obscure and evanescent, are continually born, in their turn continually to give birth, of that marriage between the beautiful thing outside and the beautiful soul within.

Hence, full æsthetic life means the creating and extending of ever new harmonies in the mind of the layman, the unconscious artist who merely enjoys, as a result of the creating and extending of new harmonies in the work of the professed artist who consciously creates. This being the case, the true æsthete is for ever seeking to reduce his impressions

and thoughts to harmony; and is for ever, accordingly, being pleased with some of them, and disgusted with others.

X

THE DESIRE FOR BEAUTY AND harmony, therefore, in proportion as it becomes active and sensitive, explores into every detail, establishes comparisons between everything, judges, approves, and disapproves; and makes terrible and wholesome havoc not merely in our surroundings, but in our habits and in our lives. And very soon the mere thought of something ugly becomes enough to outweigh the actual presence of something beautiful. I was told last winter at San Remo, that the scent of the Parma violet can be distilled only by the oil of the flower being passed through a layer of pork fat; and since that revelation violet essence has lost much of the charm it possessed for me: the thought of the suet counterbalanced the reality of the perfume.

Now this violet essence, thus obtained, is symbolic of many of the apparently refined enjoyments of our life. We shall find that luxury and pomp, delightful sometimes in themselves, are distilled through a layer of coarse and repulsive labour by other folk; and the thought of the pork suet will spoil the smell of the violets. For the more dishes we have for dinner, the greater number of cooking-pots will have to be cleaned; the more carriages and horses we use, the more washing and grooming will result; the more crowded our rooms with furniture and nicknacks, the more dust will have to be removed; the more numerous and delicate our clothes, the more brushing and folding there will be; and the more purely ornamental our own existence, the less ornamental will be that of others.

There is a *pensée* of Pascal's to the effect that a fop carries on his person the evidence of the existence of so many people devoted to his service. This thought may be delightful to a fop; but it is not pleasant to a mind sensitive to beauty and hating the bare thought of ugliness: for while vanity takes pleasure in lack of harmony between oneself and one's neighbour, æsthetic feeling takes pleasure only in harmonious relations. The thought of the servile lives devoted to make our life more beautiful counterbalances the pleasure of the beauty; 'tis the eternal question of the violet essence and the pork suet. Now the habit of beauty, the æsthetic sense, becomes, as I said, more and more sensitive and vivacious; you cannot hide from it the knowledge of every sort of detail,

you cannot prevent its noticing the ugly side, the ugly lining of certain pretty things. 'Tis a but weak and sleepy kind of æstheticism which "blinks and shuts its apprehension up" at your bidding, which looks another way discreetly, and discreetly refrains from all comparisons. The real æsthetic activity *is* an activity; it is one of the strongest and most imperious powers of human nature; it does not take orders, it only gives them. It is, when full grown, a kind of conscience of beautiful and ugly, analogous to the other conscience of right and wrong, and it is equally difficult to silence. If you can silence your æsthetic faculty and bid it be satisfied with the lesser beauty, the lesser harmony, instead of the greater, be sure that it is a very rudimentary kind of instinct; and that you are no more thoroughly æsthetic than if you could make your sense of right and wrong be blind and dumb at your convenience, you could be thoroughly moral.

Hence, the more æsthetic we become, the less we shall tolerate such modes of living as involve dull and dirty work for others, as involve the exclusion of others from the sort of life which we consider æsthetically tolerable. We shall require such houses and such habits as can be seen, and, what is inevitable in all æsthetical development, as can also be *thought of*, in all their details. We shall require a homogeneous impression of decorum and fitness from the lives of others as well as from our own, from what we actually see and from what we merely know: the imperious demand for beauty, for harmony will be applied no longer to our mere material properties, but to that other possession which is always with us and can never be taken from us, the images and feelings within our soul. Now, that other human beings should be drudging sordidly in order that we may be idle and showy means a thought, a vision, an emotion which do not get on in our mind in company with the sight of sunset and sea, the taste of mountain air and woodland freshness, the faces and forms of Florentine saints and Antique gods, the serene poignancy of great phrases of music. This is by no means all. Developing in æsthetic sensitiveness we grow to think of ourselves also, our own preferences, moods and attitudes, as more or less beautiful or ugly; the inner life falling under the same criticism as the outer one. We become aristocratic and epicurean about our desires and habits; we grow squeamish and impatient towards luxury, towards all kinds of monopoly and privilege on account of the mean attitude, the graceless gesture they involve on our own part.

XI

THIS FEELING IS INCREASING DAILY. Our deepest æsthetic emotions are, we are beginning to recognise, connected with things which we do not, cannot, possess in the vulgar sense. Nay, the deepest æsthetic emotions depend, to an appreciable degree, on the very knowledge that these things are either not such as money can purchase, or that they are within the purchasing power of all. The sense of being shareable by others, of being even shareable, so to speak, by other kinds of utility, adds a very keen attraction to all beautiful things and beautiful actions, and, of course, *vice versâ*. And things which are beautiful, but connected with luxury and exclusive possession, come to affect one as, in a way, *lacking harmonics*, lacking those additional vibrations of pleasure which enrich impressions of beauty by impressions of utility and kindliness.

Thus, after enjoying the extraordinary lovely tints—oleander pink, silver-grey, and most delicate citron—of the plaster which covers the commonest cottages, the humblest chapels, all round Genoa, there is something *short and acid* in the pleasure one derives from equally charming colours in expensive dresses. Similarly, in Italy, much of the charm of marble, of the sea-cave shimmer, of certain palace-yards and churches, is due to the knowledge that this lovely, noble substance is easy to cut and quarried in vast quantities hard by: no wretched rarity like diamonds and rubies, which diminish by the worth of a family's yearly keep if only the cutter cuts one hair-breadth wrong!

Again, is not one reason why antique sculpture awakens a state of mind where stoicism, humaneness, simplicity, seem nearer possibilities—is not one reason that it shows us the creature in its nakedness, in such beauty and dignity as it can get through the grace of birth only? There is no need among the gods for garments from silken Samarkand, for farthingales of brocade and veils of Mechlin lace like those of the wooden Madonnas of Spanish churches; no need for the ruffles and plumes of Pascal's young beau, showing thereby the number of his valets. The same holds good of trees, water, mountains, and their representation in poetry and painting; their dignity takes no account of poverty or riches. Even the lilies of the field please us, not because they toil not neither do they spin, but because they do not require, while Solomon does, that other folk should toil and spin to make them glorious.

VERNON LEE

XII

AGAIN, DO WE NOT PREFER the books which deal with habits simpler than our own? Do we not love the Odyssey partly because of Calypso weaving in her cave, and Nausicaa washing the clothes with her maidens? Does it not lend additional divinity that Christianity should have arisen among peasants and handicraftsmen?

Nay more, do we not love certain objects largely because they are useful; boats, nets, farm carts, ploughs; discovering therein a grace which actually exists, but which might else have remained unsuspected? And do we not feel a certain lack of significance and harmony of fulness of æsthetic quality in our persons when we pass in our idleness among people working in the fields, masons building, or fishermen cleaning their boats and nets; whatever beauty such things may have being enhanced by their being common and useful.

In this manner our æsthetic instinct strains vaguely after a double change: not merely giving affluence and leisure to others, but giving simplicity and utility to ourselves?

XIII

AND, EVEN APART FROM THIS, does not all true æstheticism tend to diminish labour while increasing enjoyment, because it makes the already existing more sufficient, because it furthers the joys of the spirit, which multiply by sharing, as distinguished from the pleasures of vanity and greediness, which only diminish?

XIV

YOU MAY AT FIRST FEEL inclined to pooh-pooh the notion that mere love of beauty can help to bring about a better distribution of the world's riches; and reasonably object that we cannot feed people on images and impressions which multiply by sharing; they live on bread, and not on the *idea* of bread.

But has it ever struck you that, after all, the amount of material bread—even if we extend the word to everything which is consumed for bodily necessity and comfort—which any individual can consume is really very small; and that the bad distribution, the shocking waste of this material bread arises from being, so to speak, used symbolically,

used as spiritual bread, as representing those *ideas* for which men hunger: superiority over other folk, power of having dependants, social position, ownership, and privilege of all kinds? For what are the bulk of worldly possessions to their owners: houses, parks, plate, jewels, superfluous expenditure of all kinds (and armies and navies when we come to national wastefulness)—what are all these ill-distributed riches save *ideas*, ideas futile and ungenerous, food for the soul, but food upon which the soul grows sick and corrupteth?

Would it not be worth while to reorganise this diet of ideas? To reorganise that part of us which is independent of bodily sustenance and health, which lives on spiritual commodities—the part of us including ambition, ideal, sympathy, and all that I have called *ideas*? Would it not be worth while to find such ideas as all people can live upon without diminishing each other's share, instead of the *ideas*, the imaginative satisfactions which each must refuse to his neighbour, and about which, therefore, all of us are bound to fight like hungry animals? Thus to reform our notions of what is valuable and distinguished would bring about an economic reformation; or, if other forces were needed, would make the benefits of such economic reformation completer, its hardships easier to bear; and, altering our views of loss and gain, lessen the destructive struggle of snatching and holding.

Now, as I have been trying to show, beauty, harmony, fitness, are of the nature of the miraculous loaves and fishes: they can feed multitudes and leave basketfuls for the morrow.

But the desire for such spiritual food is, you will again object, itself a rarity, a product of leisure and comfort, almost a luxury.

Quite true. And you will remember, perhaps, that I have already remarked that they are not to be expected either from the poor in material comfort, nor from the poor in soul, since both of these are condemned, the first by physical wretchedness, the second by spiritual inactivity, to fight only for larger shares of material bread; with the difference that this material bread is eaten by the poor, and made into very ugly symbols of glory by the rich.

But, among those of us who are neither hungry nor vacuous, there is not, generally speaking, much attempt to make the best of our spiritual privileges. We teach our children, as we were taught ourselves, to give importance only to the fact of exclusiveness, expense, rareness, already necessarily obtruded far too much by our struggling, imperfect civilisation. We are indeed angry with little boys and girls if they

enquire too audibly whether certain people are rich or certain things cost much money, as little boys and girls are apt to do in their very far from innocence; but we teach them by our example to think about such things every time we stretch a point in order to appear richer or smarter than we are. While, on the contrary, we rarely insist upon the intrinsic qualities for which things are really valuable, without which no trouble or money would be spent on them, without which their difficulty of obtaining would, as in the case of Dr. Johnson's musical performance, become identical with impossibility. I wonder how many people ever point out to a child that the water in a tank may be more wonderful and beautiful in its beryls and sapphires and agates than all the contents of all the jewellers' shops in Bond Street? Moreover, we rarely struggle against the standards of fashion in our habits and arrangements; which standards, in many cases, are those of our ladies' maids, butlers, tradesfolk, and in all cases the standards of our less intelligent neighbours. Nay, more, we sometimes actually cultivate in ourselves, we superfine and æsthetic creatures, a preference for such kinds of enjoyment as are exclusive and costly; we allow ourselves to be talked into the notion that solitary egoism, laborious self-assertion of ownership (as in the poor mad Ludwig of Bavaria) is a badge of intellectual distinction. We cherish a desire for the new-fangled and far-fetched, the something no other has had before; little suspecting, or forgetting, that to extract more pleasure not less, to enjoy the same things longer, and to be able to extract more enjoyment out of more things, is the sign of æsthetic vigour.

XV

STILL, ON THE WHOLE, SUCH as can care for beautiful things and beautiful thoughts are beginning to care for them more fully, and are growing, undoubtedly, in a certain moral sensitiveness which, as I have said, is coincident with æsthetic development.

This strikes me every time that I see or think about a certain priest's house on a hillside by the Mediterranean: a little house built up against the village church, and painted and roofed, like the church, a most delicate grey, against which the yellow of the spalliered lemons sings out in exquisite intensity; alongside, a wall with flower pots, and dainty white curtains to the windows. Such a house and the life possible in it are beginning, for many of us, to become the ideal, by whose side

all luxury and worldly grandeur becomes insipid or vulgar. For such a house as this embodies the possibility of living with grace and decorum *throughout* by dint of loving carefulness and self-restraining simplicity. I say with grace and decorum *throughout*, because all things which might beget ugliness in the life of others, or ugliness in our own attitude towards others, would be eliminated, thrown away like the fossil which Thoreau threw away because it collected dust. Moreover, such a life as this is such as all may reasonably hope to have; may, in some more prosperous age, obtain because it involves no hoarding of advantage for self or excluding therefrom of others.

And such a life we ourselves may attain at least in the spirit, if we become strenuous and faithful lovers of the beautiful, æsthetes and ascetics who recognise that their greatest pleasure, their only true possessions are in themselves; knowing the supreme value of their own soul, even as was foreshadowed by the Abbot Joachim of Flora, when he said that the true monk can hold no property except his lyre.

Higher Harmonies

I

"To use the beauties of earth as steps along which he mounts upwards, going from one to two, and from two to all fair forms, and from fair forms to fair actions, and from fair actions to fair notions, until from fair notions he arrives at the notion of absolute beauty, and at last knows what the essence of beauty is; this, my dear Socrates," said the prophetess of Mantineia, "is that life, above all others, which man should live, in the contemplation of beauty absolute. Do you not see that in that communion only, beholding beauty with the eye of the mind, he will be enabled to bring forth not images of beauty, but realities; for he has hold not of an image, but of a reality; and bringing forth and educating true virtue to become the friend of God, and be immortal, if mortal man may?"

Such are the æsthetics of Plato, put into the mouth of that mysterious Diotima, who was a wise woman in many branches of knowledge. As we read them nowadays we are apt to smile with incredulity not unmixed with bitterness. Is all this not mere talk, charming and momentarily elating us like so much music; itself mere beauty which, because we like it, we half voluntarily confuse with *truth*? And, on the other hand, is not the truth of æsthetics, the bare, hard fact, a very different matter? For we have learned that we human creatures will never know the absolute or the essence, that notions, which Plato took for realities, are mere relative conceptions; that virtue and truth are social ideals and intellectual abstractions, while beauty is a quality found primarily and literally only in material existences and sense-experiences; and every day we are hearing of new discoveries connecting our æsthetic emotions with the structure of eye and ear, the movement of muscles, the functions of nerve centres, nay, even with the action of heart and lungs and viscera. Moreover, all round us schools of criticism and cliques of artists are telling us forever that so far from bringing forth and educating true virtue, art has the sovereign power, by mere skill and subtlety, of investing good and evil, healthy and unwholesome, with equal merit, and obliterating the distinctions

drawn by the immortal gods, instead of helping the immortal gods to their observance.

Thus we are apt to think, and to take the words of Diotima as merely so much lovely rhetoric. But—as my previous chapters must have led you to expect—I think we are so far mistaken. I believe that, although explained in the terms of fantastic, almost mythical metaphysic, the speech of Diotima contains a great truth, deposited in the heart of man by the unnoticed innumerable experiences of centuries and peoples; a truth which exists in ourselves also as an instinctive expectation, and which the advance of knowledge will confirm and explain. For in that pellucid atmosphere of the Greek mind, untroubled as yet by theoretic mists, there may have been visible the very things which our scientific instruments are enabling us to see and reconstruct piecemeal, great groupings of reality metamorphosed into Fata Morgana cities seemingly built by the gods.

And thus I am going to try to reinstate in others' belief, as it is fully reinstated in my own, the theory of higher æsthetic harmonies, which the prophetess of Mantineia taught Socrates: to wit, that through the contemplation of true beauty we may attain, by the constant purification—or, in more modern language, the constant selecting and enriching—of our nature, to that which transcends material beauty; because the desire for harmony begets the habit of harmony, and the habit thereof begets its imperative desire, and thus on in never-ending alternation.

II

PERHAPS THE BEST WAY OF expounding my reasons will be to follow the process by which I reached them; for so far from having started with the theory of Diotima, I found the theory of Diotima, when I re-read it accidentally after many years' forgetfulness, to bring to convergence the result of my gradual experience.

THINKING ABOUT THE HERMES OF Olympia, and the fact that so far he is pretty well the only Greek statue which historical evidence unhesitatingly gives us as an original masterpiece, it struck me that, could one become really familiar with him, could eye and soul learn all the fulness of his perfection, we should have the true starting-point for knowledge of the antique, for knowledge, in great measure, of all art.

Yes, and of more than art, or rather of art in more than one relation.

Is this a superstition, a mere myth, perhaps, born of words? I think not. Surely if we could really arrive at knowing such a masterpiece, so as to feel rather than see its most intimate organic principles, and the great main reasons separating it from all inferior works and making it be itself: could we do this, we should know not merely what art is and should be, but, in a measure, what life should be and might become: what are the methods of true greatness, the sensations of true sanity.

It would teach us the eternal organic strivings and tendencies of our soul, those leading in the direction of life, leading away from death.

If this seems mere allegory and wild talk, let us look at facts and see what art is. For is not art inasmuch as untroubled by the practical difficulties of existence, inasmuch as the free, unconscious attempt of all nations and generations to satisfy, outside life, those cravings which life still leaves unsatisfied—is not art a delicate instrument, showing in its sensitive oscillations the most intimate movements and habits of the soul? Does it not reveal our most recondite necessities and possibilities, by sifting and selecting, reinforcing or attenuating, the impressions received from without; showing us thereby how we must stand towards nature and life, how we must feel and be?

And this most particularly in those spontaneous arts which, first in the field, without need of adaptations of material or avoidance of the already done, without need of using up the rejected possibilities of previous art, or awakening yet unknown emotions, are the simple, straightforward expression, each the earliest satisfactory one in its own line, of the long unexpressed, long integrated, organic wants and wishes of great races of men: the arts, for instance, which have given us that Hermes, Titian's pictures, and Michael Angelo's and Raphael's frescoes; given us Bach, Gluck, Mozart, the serener parts of Beethoven, music of yet reserved pathos, braced, spring-like strength, learned, select: arts which never go beyond the universal, averaged expression of the soul's desires, because the desires themselves are sifted, limited to the imperishable and unchangeable, like the artistic methods which embody them, reduced to the essential by the long delay of utterance, the long—century long—efforts to utter.

Becoming intimate with such a statue as the Olympian Hermes, and comparing the impressions received from it with the impressions both of inferior works of the same branch of art and with the impressions of equally great works—pictures, buildings, musical compositions—of

other branches of art, becoming conversant with the difference between an original and a copy, great art and poor art, we gradually become aware of a quality which exists in all good art and is absent in all bad art, and without whose presence those impressions summed up as beauty, dignity, grandeur, are never to be had. This peculiarity, which most people perceive and few people define—explaining it away sometimes as *truth*, or taking it for granted under the name of *quality*—this peculiarity I shall call for convenience' sake harmony; for I think you will all of you admit that the absence or presence of harmony is what distinguishes bad art from good. Harmony, in this sense—and remember that it is this which connoisseurs most usually allude to as *quality*—harmony may be roughly defined as the organic correspondence between the various parts of a work of art, the functional interchange and interdependence thereof. In this sense there is harmony in every really living thing, for otherwise it could not live. If the muscles and limbs, nay, the viscera and tissues, did not adjust themselves to work together, if they did not in this combination establish a rhythm, a backward-forward, contraction-relaxation, taking-in-giving-out, diastole-systole in all their movements, there would be, instead of a living organism, only an inert mass. In all living things, and just in proportion as they are really alive (for in most real things there is presumably some defect of rhythm tending to stoppage of life), there is bound to be this organic interdependence and interchange. Natural selection, the survival of such individuals and species as best work in with, are most rhythmical to, their surroundings—natural selection sees to that.

III

IN ART THE PLACE OF natural selection is taken by man's selection; and all forms of art which man keeps and does not send into limbo, all art which man finds suitable to his wants, rhythmical with his habits, must have that same quality of interdependence of parts, of interchange of function. Only in the case of art, the organic necessity refers not to outer surroundings, but to man's feeling; in fact, man's emotion constitutes necessity towards art, as surrounding nature constitutes necessity for natural objects. Now man requires organic harmony, that is, congruity and co-ordination of processes, because his existence, the existence of every cell of him, depends upon it, is one complete microcosm of interchange, of give-and-take, diastole-systole, of rhythm and harmony;

and therefore all such things as give him impressions of the reverse thereof, go against him, and in a greater or lesser degree, threaten, disturb, paralyse, in a way poison or maim him. Hence he is for ever seeking such congruity, such harmony; and his artistic creativeness is conditioned by the desire for it, nay, is perhaps mainly seeking to obtain it. Whenever he spontaneously and truly creates artistic forms, he obeys the imperious vital instinct for congruity; nay, he seeks to eke out the insufficient harmony between himself and the things which he *cannot* command, the insufficient harmony between the uncontrollable parts of himself, by a harmony created on purpose in the things which he *can* control. To a large extent man feels himself tortured by discordant impressions coming from the world outside and the world inside him; and he seeks comfort and medicine in harmonious impressions of his own making, in his own strange inward-outward world of art.

This, I think, is the true explanation of that much-disputed-over *ideal*, which, according to definitions, is perpetually being enthroned and dethroned as the ultimate aim of all art: the ideal, the imperatively clamoured-for mysterious something, is neither conformity to an abstract idea, nor conformity to actual reality, nor conformity to the typical, nor conformity to the individual; it is, I take it, simply conformity to man's requirements, to man's inborn and peremptory demand for greater harmony, for more perfect co-ordination and congruity in his feelings.

Now, when, in the exercise of the artistic instincts, mankind are partially obeying some other call than this one—the desire for money, fame, or for some intellectual formula—things are quite different, and there is no production of what I have called harmony. There is no congruity when even great people set about doing pseudo-antique sculpture in Canova-Thorwaldsen fashion because Winckelmann and Goethe have made antique sculpture fashionable; there is no congruity when people set to building pseudo-Gothic in obedience to the romantic movement and to Ruskin. For neither the desire for making a mark, nor the most conscientious pressure of formula gives that instinct of selection and co-ordination characterising even the most rudimentary artistic efforts in the most barbarous ages, when men are impelled merely and solely by the æsthetic instinct. Moreover, where people do not want and need (as they want and need food or drink or warmth or coolness) one sort of effect, that is to say, one arrangement of impressions rather than another, they are sure to be deluded by the mere

arbitrary classification, the mere *names* of things. They will think that smooth cheeks, wavy hair, straight noses, limbs of such or such measure, attitude, and expression, set so, constitute the Antique; that clustered pillars, cross vaulting, spandrils, and Tudor roses make Gothic. But the Antique quality is the particular and all permeating relation between all its items; and Gothic the particular and all permeating relation between those other ones; and unless you aim at the *specific emotion* of Antique or Gothic, unless you feel the imperious call for the special harmony of either, all the measurements and all the formulas will not avail. While, on the contrary, people without any formula or any attempt at imitation, like the Byzantine architects and those of the fifteenth century, merely because they are obeying their own passionate desire for congruity of impressions, for harmony of structure and function, will succeed in creating brand-new, harmonious, organic art out of the actual details, sometimes the material ruins, of an art which has passed away.

If we become intimate with any great work of art, and intimate in so far with the thoughts and emotions it awakens in ourselves, we shall find that it possesses, besides this congruity within itself which assimilates it to all really living things, a further congruity, not necessarily found in real objects, but which forms the peculiarity of the work of art, a congruity with ourselves; for the great work of art is vitally connected with the habits and wants, the whole causality and rhythm of mankind; it has been fitted thereto as the boat to the sea.

IV

IN THIS MANNER CAN WE learn from art the chief secret of life: the secret of action and reaction, of causal connection, of suitability of part to part, of organism, interchange, and growth.

And when I say *learn*, I mean learn in the least official and the most efficacious way. I do not mean merely that, looking at a statue like the Hermes, a certain fact is borne in upon our intelligence, the fact of all vitality being dependent on harmony. I mean that perhaps, nay probably, without any such formula, our whole nature becomes accustomed to a certain repeated experience, our whole nature becomes adapted thereunto, and acts and reacts in consequence, by what we call intuition, instinct. It is not with our intellect alone that we possess such a fact, as we might intellectually possess that twice two is four, or that Elizabeth was the daughter of Henry VIII, knowing casually what we may

casually also forget; we possess, in such a way that forgetting becomes impossible, with our whole soul and our whole being, re-living that fact with every breath that we draw, with every movement we make, the first great lesson of art, that vitality means harmony. Let us look at this fact, and at its practical applications, apart from all æsthetic experience.

All life is harmony; and all improvement in ourselves is therefore, however unconsciously, the perceiving, the realising, or the establishing of harmonies, more minute or more universal. Yes, curious and unpractical as it may seem, harmonies, or, under their humbler separate names—arrangements, schemes, classifications, are the chief means for getting the most out of all things, and particularly the most out of ourselves.

For they mean, first of all, unity of means for the attaining of unity of effect, that is to say, incalculable economy of material, of time, and of effort; and secondly, unity of effect produced, that is to say, economy even greater in our power of perceiving and feeling: nothing to eliminate, nothing against whose interruptions we waste our energy, our power of becoming more fit in the course of striving.

When there exists harmony one impression leads to, enhances another; we, on the other hand, unconsciously recognise at once what is doing to us, what we in return must do; the mood is indicated, fulfilled, consummated; in plenitude we feel, we are; and in plenitude of feeling and being, we, in our turn, *do*. Neither is such habit of harmony, of scheme, of congruity, a mere device for sucking the full sweetness out of life, although, heaven knows, that were important enough. As much as such a habit husbands, and in a way multiplies, life's sweetness; so likewise does it husband and multiply man's power. For there is no quicker and more thorough mode of selecting among our feelings and thoughts than submitting them to a standard of congruity; nothing more efficacious than the question: "Is such or such a notion or proceeding harmonious with what we have made the rest of our life, with what we wish our life to be?" This is, in other words, the power of the *ideal*, the force of *ideas*, of thought-out, recognised habits, as distinguished from blind helter-skelter impulse. This is what welds life into one, making its forces work not in opposition but in concordance; this is what makes life consecutive, using the earlier act to produce the later, tying together existence in an organic fatality of *must be*: the fatality not of the outside and the unconscious, but of the conscious, inner, upper man. Nay, it is what makes up the *Ego*. For the *ego*, as we are beginning to understand,

is no mysterious separate entity, still less a succession of disconnected, conflicting, blind impulses; the *ego* is the congruous, perceived, nay, thought-out system of habits, which feels all incongruity towards itself as accidental and external. Hence, when we ask which are the statements we believe in, we answer instinctively (logic being but a form of congruity) those statements which accord with themselves and with other statements; when we ask, which are the persons we trust? we answer, those persons whose feelings and actions are congruous with themselves and with the feelings and actions of others. And, on the contrary, it is in the worthless, in the degenerate creature, that we note moods which are destructive to one another's object, ideas which are in flagrant contradiction; and it is in the idiot, the maniac, the criminal, that we see thoughts disconnected among themselves, perceptions disconnected with surrounding objects, and instincts and habits incompatible with those of other human beings. Nay, if we look closely, we shall recognise, moreover, that those emotions of pleasure are the healthy, the safe ones, which are harmonious not merely in themselves (as a musical note is composed of even vibrations), but harmonious with all preceding and succeeding pleasures in ourselves, and harmonious, congruous, with the present and future pleasures in others.

V

THE INSTINCT OF CONGRUITY, OF subordination of part to whole, the desire for harmony which is fostered above all things by art, is one of the most precious parts of our nature, if only, obeying its own tendency to expand, we apply it to ever wider circles of being; not merely to the accessories of living, but to life itself.

For this love of harmony and order leads us to seek what is most necessary in our living: a selection of the congruous, an arrangement of the mutually dependent in our thoughts and feelings.

Much of the work of the universe is done, no doubt, by what seems the exercise of mere random energy, by the thinking of apparently disconnected thoughts and the feeling of apparently sporadic impulses; but if the thought and the impulse remained really disconnected and sporadic, half would be lost and half would be distorted. It is one of the economical adaptations of nature that every part of us tends not merely to be consistent with itself, to eliminate the hostile, to beget the similar, but tends also to be connected with other parts; so that, action coming

in contact with action, thought in contact with thought, and feeling in contact with feeling, each single one will be strengthened or neutralised by the other. And it is the especial business of what we may call the central consciousness, the dominant thought or emotion, to bring these separate thoughts and impulses, these separate groups thereof, into more complex relations, to continue on a far vaster scale that vital contact, that trying of all things by the great trial of affinity or repulsion, of congruity or incongruity. Thus we make trial of ourselves; and by the selfsame process, by the test of affinity and congruity, the silent forces of the universe make trial of *us*, rejecting or accepting, allowing us, our thoughts, our feelings to live and be fruitful, or condemning us and them to die in barrenness.

Whither are we going? In what shape shall the various members of our soul proceed on their journey; which forming the van, which the rear and centre? Or shall there be neither van, nor rear, nor wedge-like forward flight?

If this question remains unasked or unanswered, our best qualities, our truest thoughts and purest impulses, may be hopelessly scattered into distant regions, become defiled in bad company, or, at least, barren in isolation; the universal life rejecting or annihilating them.

How often do we not see this! Natures whose various parts have rambled asunder, or have come to live, like strangers in an inn, casually, promiscuously, each refusing to be his brother's keeper: instincts of kindliness at various ends, unconnected, unable to coalesce and conquer; thoughts separated from their kind, incapable of application; and, in consequence, strange superficial comradeships, shoulder-rubbings of true and false, good and evil, become indifferent to one another, incapable of looking each other in the face, careless, unblushing. Nay, worse. For lack of all word of command, of all higher control, hostile tendencies accommodating themselves to reign alternate, sharing the individual in distinct halves, till he becomes like unto that hero of Gautier's witch story, who was a pious priest one-half of the twenty-four hours and a wicked libertine the other: all power of selection, of reaction gone in this passive endurance of conflicting tendencies; all identity gone, save a mere feeble outsider looking on at the alternations of intentions and lapses, of good and bad. And the soul of such a person—if, indeed, we can speak of one soul or one person where there exists no unity—becomes like a jangle of notes belonging to different tonalities, alternating and mingling in hideous confusion for lack of a

clear thread of melody, a consistent system of harmony, to select, reject, and keep all things in place.

Melody, harmony: the two great halves of the most purely æsthetic of all arts, symbolise, as we might expect, the two great forces of life: consecutiveness and congruity, under their different names of intention, fitness, selection, adaptation. These are what make the human soul like a conquering army, a fleet freighted with riches, a band of priests celebrating a rite. And this is what art, by no paltry formula, but by the indelible teaching of habit, of requirement, and expectation become part of our very fibre—this is what art can teach to those who will receive its highest lesson.

VI

THOSE WHO CAN RECEIVE THAT lesson, that is to say, those in whom it can expand and ramify to the fulness and complexity which is its very essence. For it happens frequently enough that we learn only a portion of this truth, which by this means is distorted into error. We accept the æsthetic instinct as a great force of Nature; but, instead of acknowledging it as our master, as one of the great lords of life, of whom Emerson spoke, we try to make it our servant. We attempt to get congruity between the details of our everyday existence, and refuse to seek for congruity between ourselves and the life which is greater than ours.

A friend of mine, who had many better ways of spending her money, was unable one day to resist the temptation of buying a beautiful old majolica inkstand, which, not without a slight qualm of conscience, she put into a very delightful old room of her house. The room had an inkstand already, but it was of glass, and modern. "This one is in harmony with the rest of the room," she said, and felt fully justified in her extravagance. It is this form, or rather this degree, of æstheticism, which so often prevents our realising the higher æsthetic harmonies. In obedience to a perception of what is congruous on a small scale we often do oddly incongruous things: spend money we ought to save, give time and thought to trifles while neglecting to come to conclusions about matters of importance; endure, or even cultivate, persons with whom we have less than no sympathy; nay, sometimes, from a keen sense of incongruity, tune down our thoughts and feelings to the flatness of our surroundings. The phenomenon of what may thus result

from a certain æsthetic sensitiveness is discouraging, and I confess that it used to discourage and humiliate me. But the philosophy which the prophetess of Mautineia taught Socrates settles the matter, and solves, satisfactorily what in my mind I always think of as the question of the majolica inkstand.

Diotima, you will remember, did not allow her disciple to remain engrossed in the contemplation of one kind of beauty, but particularly insisted that he should use various fair forms as steps by which to ascend to the knowledge of ever higher beauties. And this I should translate into more practical language by saying that, in questions like that of the majolica inkstand, we require not a lesser sensitiveness to congruity, but a greater; that we must look not merely at the smaller, but at the larger items of our life, asking ourselves, "Is this harmonious? or is it, seen in some wider connection, even like that clumsy glass inkstand in the oak panelled and brocade hung room?" If we ask ourselves this, and endeavour to answer it faithfully—with that truthfulness which is itself an item of *consistency*—we may find that, strange as it may seem, the glass inkstand, ugly as it is in itself, and out of harmony with the furniture, is yet more congruous, and that we actually prefer it to the one of majolica.

And it is in connection with this that I think that many persons who are really æsthetic, and many more who imagine themselves to be so, should foster a wholesome suspicion of the theory which makes it a duty to accumulate certain kinds of possessions, to seek exclusively certain kinds of impressions, on the score of putting beauty and dignity into our lives.

Put beauty, dignity, harmony, serenity into our lives. It sounds very fine. But *can* we? I doubt it. We may put beautiful objects, dignified manners, harmonious colours and shapes, but can we put dignity, harmony, or beauty? Can we put them into an individual life; can anything be put into an individual life save furniture and garments, intellectual as well as material? For an individual life, taken separately, is a narrow, weak thing at the very best; and everything we can put into it, everything we lay hold of for the sake of putting in, must needs be small also, merely the chips or dust of great things; or if it have life, must be squeezed, cut down, made so small before it can fit into that little receptacle of our egoism, that it will speedily be a dead, dry thing: thoughts once thought, feelings once felt, now neither thought nor felt, merely lying there inert, as a dead fact, in our sterile self. Do we not see

this on all sides, examples of life into which all the dignified things have been crammed and all the beautiful ones, and which despite the statues, pictures, poems, and symphonies within its narrow compass, is yet so far from dignified or beautiful?

But we need not trouble about dignity and beauty coming to our life so long as we veritably and thoroughly *live*; that is to say, so long as we try not to put anything into our life, but to put our life into the life universal. The true, expanding, multiplying life of the spirit will bring us in contact, we need not fear, with beauty and dignity enough, for there is plenty such in creation, in things around us, and in other people's souls; nay, if we but live to our utmost power the life of all things and all men, seeing, feeling, understanding for the mere joy thereof, even our individual life will be invested with dignity and beauty in our own eyes.

But furniture will not do it, nor dress, nor exquisite household appointments; nor any of the things, books, pictures, houses, parks, of which we can call ourselves owners. I say *call* ourselves: for can we be sure we really possess them? And thus, if we think only of our life, and the decking thereof, it is only furniture, garments, and household appointments we can deal with; for beauty and dignity cannot be confined in so narrow a compass.

VII

I HAVE SPOKEN SO FAR of the conscious habit of harmony, and of its conscious effect upon our conduct. I have tried to show that the desire for congruity, which may seem so trivial a part of mere dilettanteist superfineness, may expand and develop into such love of harmony between ourselves and the ways of the universe as shall make us wince at other folks' loss united to our gain, at our deterioration united to our pleasure, even as we wince at a false note or a discordant arrangement of colours.

But there is something more important than conscious choice, and something more tremendous than definite conduct, because conscious choice and conduct are but its separate and plainly visible results. I mean unconscious way of feeling and organic way of living: that which, in the language of old-fashioned medicine, we might call the complexion or habit of the soul.

This is undoubtedly affected by conscious knowledge and reason, as it undoubtedly manifests itself in both. But it is, I believe, much more

what we might call a permanent emotional condition, a particular way of feeling, of reacting towards the impressions given us by the universe. And I believe that the individual is sound, that he is capable of being happy while increasing the happiness of others, or the reverse, according as he reacts harmoniously or inharmoniously towards those universal impressions. And here comes in what seems to me the highest benefit we can receive from art and from the æsthetic activities, which, as I have said before, are in art merely specialised and made publicly manifest.

VIII

THE HABIT OF BEAUTY, OF harmony, is but the habit, engrained in our nature by the unnoticed experiences of centuries, of *life* in our surroundings and in ourselves; the habit of beauty is the habit, I believe scientific analysis of nature's ways and means will show us—of the growing of trees, the flowing of water, the perfect play of perfect muscles, all registered unconsciously in the very structure of our soul. And for this reason every time we experience afresh the particular emotion associated with the quality *beautiful*, we are adding to that rhythm of life within ourselves by recognising the life of all things. There is not room within us for two conflicting waves of emotion, for two conflicting rhythms of life, one sane and one unsound. The two may possibly alternate, but in most cases the weaker will be neutralised by the stronger; and, at all events, they cannot co-exist. We can account, only in this manner, for the indisputable fact that great emotion of a really and purely æsthetic nature has a morally elevating quality, that as long as it endures—and in finer organisations its effect is never entirely lost—the soul is more clean and vigorous, more fit for high thoughts and high decisions. All understanding, in the wider and more philosophical sense, is but a kind of becoming: our soul experiences the modes of being which it apprehends. Hence the particular religious quality (all faiths and rituals taking advantage thereof) of a high and complex æsthetic emotion. Whenever we come in contact with real beauty, we become aware, in an unformulated but overwhelming manner, of some of the immense harmonies of which all beauty is the product, of which all separate beautiful things are, so to speak, the single patterns happening to be in our line of vision, while all around other patterns connect with them, meshes and meshes of harmonies,

spread out, outside our narrow field of momentary vision, an endless web, like the constellations which, strung on their threads of mutual dependence, cover and fill up infinitude.

In the moments of such emotional perception, our soul also, ourselves, become in a higher degree organic, alive, receiving and giving out the life of the universe; come to be woven into the patterns of harmonies, made of the stuff of reality, homogeneous with themselves, consubstantial with the universe, like the living plant, the flowing stream, the flying cloud, the great picture or statue.

And in this way is realised, momentarily, but with ever-increasing power of repetition, that which, after the teaching of Diotima, Socrates prayed for—"the harmony between the outer and the inner man."

But this, I know, many will say, is but a delusion. Rapture is pleasant, but it is not necessarily, as the men of the Middle Ages thought, a union with God. And is this the time to revive, or seek to revive, when science is for ever pressing upon us the conclusion that soul is a function of matter—is this the time to revive discredited optimistic idealisms of an unscientific philosophy?

But if science become omniscient, it will surely recognise and explain the value of such recurring optimistic idealisms; and if the soul be a function of matter, will not science recognise but the more, that the soul is an integral and vitally dependent portion of the material universe?

IX

BE THIS AS IT MAY, one thing seems certain, that the artistic activities are those which bring man into emotional communion with external nature; and that such emotional communion is necessary for man's thorough spiritual health. Perception of cause and effect, generalisation of law, reduces the universe indeed to what man's intellect can grasp; but in the process of such reduction to the laws of man's thought, the universe is shorn of its very power to move man's emotion and overwhelm his soul. The abstract which we have made does not vivify us sufficiently. And the emotional communion of man with nature is through those various faculties which we call æsthetic. It is not to no purpose that poetry has for ever talked to us of skies and mountains and waters; we require, for our soul's health, to think about them otherwise than with reference to our material comfort and discomfort; we require to feel that they and ourselves are brethren united by one great law of

life. And what poetry suggests in explicit words, bidding us love and be united in love to external nature; art, in more irresistible because more instinctive manner, forces upon our feelings, by extracting, according to its various kinds, the various vital qualities of the universe, and making them act directly upon our mind: rhythms of all sorts, static and dynamic, in the spatial arts of painting and sculpture; in the half spatial, half temporal art of architecture: in music, which is most akin to life, because it is the art of movement and change.

X

WE CAN ALL REMEMBER MOMENTS when we have seemed conscious, even to overwhelming, of this fact. In my own mind it has become indissolubly connected with a certain morning at Venice, listening to the organ in St. Mark's.

Any old and beautiful church gives us all that is most moving and noblest—organism, beauty, absence of all things momentary and worthless, exclusion of grossness, of brute utility and mean compromise, equality of all men before God; moreover, time, eternity, the past, and the great dead. All noble churches give us this; how much more, therefore, this one, which is noblest and most venerable!

It has, like no other building, been handed over by man to Nature; Time moulding and tinting into life this structure already so organic, so fit to live. For its curves and vaultings, its cupolas mutually supported, the weight of each carried by all; the very colour of the marbles, brown, blond, living colours, and the irregular symmetry, flower-like, of their natural patterning, are all seemingly organic and ready for life. Time has added that, with the polish and dimming alternately of the marbles, the billowing of the pavement, the slanting of the columns, and last, but not least, the tarnishing of the gold and the granulating of the mosaic into an uneven surface: the gold seeming to have become alive and in a way vegetable, and to have faded and shrunk like autumn leaves.

XI

THE MORNING I SPEAK OF they were singing some fugued composition by I know not whom. How well that music suited St. Mark's! The constant interchange of vault and vault, cupola and cupola, column and column, handing on their energies to one another; the springing up of

new details gathered at once into the great general balance of lines and forces; all this seemed to find its natural voice in that fugue, to express, in that continuous revolution of theme chasing, enveloping theme, its own grave emotion of life everlasting: Being, becoming; becoming, being.

XII

IT IS SUCH AN ALTERNATION as this, ceaseless, rhythmic, which constitutes the upward life of the soul: that life of which the wise woman of Mantineia told Socrates that it might be learned through faithful and strenuous search for ever widening kinds of beauty, the "life above all," in the words of Diotima, "which a man should live."

The life which vibrates for ever between being better and conceiving of something better still; between satisfaction in harmony and craving for it. The life whose rhythm is that of happiness actual and happiness ideal, alternating for ever, for ever pressing one another into being, as the parts of a fugue, the dominant and the tonic. Being, becoming; becoming, being; idealising, realising; realising, idealising.

Beauty and Sanity

I

OUT OF LONDON AT LAST; at last, though after only two months!
Not, indeed, within a walk of my clump of bay-trees on the Fiesole
hill; but in a country which has some of that Tuscan grace and serene
austerity, with its Tweed, clear and rapid in the wide shingly bed, with
its volcanic cones of the Eildons, pale and distinct in the distance: river
and hills which remind me of the valley where the bay-trees grow, and
bring to my mind all that which the bay-trees stand for.

There is always something peculiar in these first hours of finding
myself once more alone, once more quite close to external things; the
human jostling over, an end, a truce at least, to "all the neighbours'
talk with man and maid—such men—all the fuss and trouble of street
sounds, window-sights" (how he knew these things, the poet!); once
more in communion with the things which somehow—nibbled grass
and stone-tossed water, yellow ragwort in the fields, blue cranesbill
along the road, big ash-trees along the river, sheep, birds, sunshine, and
showers—somehow contrive to keep themselves in health, to live, grow,
decline, die, be born again, without making a mess or creating a fuss. The
air, under the grey sky, is cool, even cold, with infinite briskness. And
this impression of briskness, by no means excluded by the sense of utter
isolation and repose, is greatly increased by a special charm of this place,
the quantity of birds to listen to and watch; great blackening flights of
rooks from the woods along the watercourses and sheltered hillsides
(for only solitary ashes and wind-vexed beeches will grow in the open);
peewits alighting with squeals in the fields; blackbirds and thrushes
in the thick coverts (I found a poor dead thrush with a speckled chest
like a toad, laid out among the beech-nuts); wagtails on the shingle,
whirling over the water, where the big trout and salmon leap; every sort
of swallow; pigeons crossing from wood to wood; wild duck rattling
up, and seagulls circling above the stream; nay, two herons, standing
immovable, heraldic, on the grass among the sheep.

In such moments, with that briskness transferred into my feelings,
life seems so rich and various. All pleasant memories come to my
mind like tunes, and with real tunes among them (making one realise
that the greatest charm of music is often when no longer materially

audible). Pictures also of distant places, tones of voice, glance of eyes of dear friends, visions of pictures and statues, and scraps of poems and history. More seems not merely to be brought to me, but more to exist, wherewith to unite it all, within myself.

Such moments, such modes of being, ought to be precious to us; they and every impression, physical, moral, æsthetic, which is akin to them, and we should recognise their moral worth. Since it would seem that even mere bodily sensations, of pure air, bracing temperature, vigor of muscles, efficiency of viscera, accustom us not merely to health of our body, but also, by the analogies of our inner workings, to health of our soul.

II

HOW DELICATE AN ORGANISM, HOW alive with all life's dangers, is the human character; and how persistently do we consider it as the thing of all others most easily forced into any sort of position, most safely handled in ignorance! Surely some of the misery, much of the waste and deadlock of the world are due to our all being made of such obscure, unguessed at material; to our not knowing it betimes, and others not admitting it even late in the day. When, for instance, shall we recognise that the bulk of our psychic life is unconscious or semi-unconscious, the life of long-organised and automatic functions; and that, while it is absurd to oppose to these the more recent, unaccustomed and fluctuating activity called *reason*, this same reason, this conscious portion of ourselves, may be usefully employed in understanding those powers of nature (powers of chaos sometimes) within us, and in providing that these should turn the wheel of life in the right direction, even like those other powers of nature outside us, which reason cannot repress or alter, but can understand and put to profit. Instead of this, we are ushered into life thinking ourselves thoroughly conscious throughout, conscious beings of a definite and stereotyped pattern; and we are set to do things we do not understand with mechanisms which we have never even been shown: Told to be good, not knowing why, and still less guessing how!

Some folk will answer that life itself settles all that, with its jostle and bustle. Doubtless. But in how wasteful, destructive, unintelligent, and cruel a fashion! Should we be satisfied with this kind of surgery, which cures an ache by random chopping off a limb; with this elementary

teaching, which saves our body from the fire by burning our fingers? Surely not; we are worth more care on our own part.

The recognition of this, and more especially of the manner in which we may be damaged by dangers we have never thought of as dangers, our souls undermined and made boggy by emotions not yet classified, brings home to me again the general wholesomeness of art; and also the fact that, wholesome as art is, in general, and, compared with the less abstract activities of our nature, there are yet differences in art's wholesomeness, there are categories of art which can do only good, and others which may also do mischief.

Art, in so far as it moves our fancies and emotions, as it builds up our preferences and repulsions, as it disintegrates or restores our vitality, is merely another of the great forces of nature, and we require to select among its activities as we select among the activities of any other natural force. . . When, I wonder, I wonder, will the forces *within* us be recognised as natural, in the same sense as those *without*; and our souls as part of the universe, prospering or suffering, according to which of its rhythms they vibrate to: the larger rhythm, which is for ever increasing, and which means happiness; the smaller, for ever slackening, which means misery?

III

BUT SINCE LIFE HAS GOT two rhythms, why should art have only one? Our poor mankind by no means always feel braced, serene, and energetic; and we are far from necessarily keeping step with the movements of the universe which imply happiness.

Let alone the fact of wretched circumstances beyond our control, of natural decay and death, and loss of our nearest and dearest; the universe has made it excessively difficult, nay, impossible, for us to follow constantly its calm behest, "Be as healthy as possible." It is all very fine to say *be healthy*. Of course we should be willing enough. But it must be admitted that the Powers That Be have not troubled about making it easy. Be healthy indeed! When health is so nicely balanced that it is at the mercy of a myriad of microscopic germs, of every infinitesimal increase of cold or heat, or damp or dryness, of alternations of work and play, oscillation of want and excess incalculably small, any of which may disturb the beautiful needle-point balance and topple us over into disease. Such Job's comforting is one of the many sledge-hammer

ironies with which the Cosmos diverts itself at our expense; and of course the Cosmos may permit itself what it likes, and none of us can complain. But is it possible for one of ourselves, a poor, sick, hustled human being, to take up the jest of the absentee gods of Lucretius, and say to his fellow-men: "Believe me, you would do much better to be quite healthy, and quite happy?"

And, as art is one of mankind's modes of expressing itself, why in the world should we expect it to be the expression only of mankind's health and happiness? Even admitting that the very existence of the race proves that the healthy and happy states of living must on the whole preponderate (a matter which can, after all, not be proved so easily), even admitting that, why should mankind be allowed artistic emotions only at those moments, and requested not to express itself or feel artistically during the others? Bay-trees are delightful things, no doubt, and we are all very fond of them off and on. But why must we pretend to enjoy them when we don't; why must we hide the fact that they sometimes irritate or bore us, and that every now and then we very much prefer—well, weeping-willows, upas-trees, and all the livid or phosphorescent eccentricities of the various *fleurs du mal*?

Is it not stupid thus to "blink and shut our apprehension up?" Nay, worse, is it not positively heartless, brutal?

IV

THIS ARGUMENT, I CONFESS, INVARIABLY delights and humiliates me: it is so full of sympathy for all sorts and conditions of men, and so appreciative of what is and what is not. It is so very human and humane. There is in it a sort of quite gentle and dignified Prometheus Vinctus attitude towards the Powers That Be; and Zeus, with his thunderbolts and chains, looks very much like a brute by contrast.

But what is to be done? Zeus exists with his chains and thunderbolts, and all the minor immortals, lying down, colossal, dim, like mountains at night, at Schiller's golden tables, each with his fine attribute, olive-tree, horse, lyre, sun and what not, by his side; also his own particular scourge, plague, dragon, wild boar, or sea monster, ready to administer to recalcitrant, insufficiently pious man. And the gods have it their own way, call them what you will, children of Chaos or children of Time, dynasty succeeding dynasty, but only for the same old gifts and same old scourges to be handed on from one to the other.

In more prosaic terms, we cannot get loose of nature, the nature of ourselves; we cannot get rid of the fact that certain courses, certain habits, certain preferences are to our advantage, and certain others to our detriment. And therefore, to return to art, and to the various imaginative and emotional activities which I am obliged to label by that very insufficient name, we cannot get rid of the fact that, however much certain sorts of art are the natural expression of certain recurring and common states of being; however much certain preferences correspond to certain temperaments or conditions, we must nevertheless put them aside as much as possible, and give our attention to the opposite sorts of art and the opposite sorts of preference, for the simple reason that the first make us less fit for life and less happy in the long run, while the second make us more fit and happier.

It is a question not of what we *are*, but of what *we shall be*.

V

A DISTINGUISHED SCIENTIFIC PSYCHOLOGIST, WHO is also a psychologist in the unscientific sense, and who writes of Intellect and Will less in the spirit (and, thank heaven, less in the style) of Mr. Spencer than in that of Monsieur de Montaigne, has objected to music (and, I presume, in less degree to other art) that it runs the risk of enfeebling the character by stimulating emotions without affording them a corresponding outlet in activity. I agree (as will be seen farther on) that music more particularly may have an unwholesome influence, but not for the reason assigned by Professor James, who seems to me to mistake the nature and functions of artistic emotion.

I doubt very much whether any non-literary art, whether even music has the power, in the modern man, of stimulating tendencies to action. It may have had in the savage, and may still have in the civilised child; but in the ordinary, cultivated grown-up person, the excitement produced by any artistic sight, sound, or idea will most probably be used up in bringing to life again some of the many millions of sights, sounds, and ideas which lie inert, stored up in our mind. The artistic emotion will therefore not give rise to an active impulse, but to that vague mixture of feelings and ideas which we call a *mood*; and if any alteration occur in subsequent action, it will be because all external impressions must vary according to the mood of the person who receives them, and consequently undergo a certain selection, some being

allowed to dominate and lead to action, while others pass unnoticed, are neutralised or dismissed.

More briefly, it seems to me that artistic emotion is of practical importance, not because it discharges itself in action, but, on the contrary, because it produces a purely internal rearrangement of our thoughts and feelings; because, in short, it helps to form concatenations of preferences, habits of being.

Whether or not Mr. Herbert Spencer be correct in deducing all artistic activities from our primæval instincts of play, it seems to me certain that these artistic activities have for us adults much the same importance as the play activities have for a child. They represent the only perfectly free exercise, and therefore, free development, of our preferences. Now, everyone will admit, I suppose, that it is extremely undesirable that a child should amuse itself acquiring unwholesome preferences and evil habits, indulging in moods which will make it or its neighbours less comfortable out of play-time?

Mind, I do not for a moment pretend that art is to become the conscious instrument of morals, any more than (Heaven forbid!) play should become the conscious preparation of infant virtue. All I contend is that if some kinds of infant amusement result in damage, we suppress them as a nuisance; and that, if some kinds of art disorganise the soul, the less we have of them the better.

Moreover, the grown-up human being is so constituted, is so full of fine connections and analogies throughout his nature, that, while the sense of emulation and gain lends such additional zest to his amusements, the sense of increasing spiritual health and power, wherever it exists, magnifies almost incredibly the pleasure derivable from beautiful impressions.

VI

THE PERSONS WHO MAINTAINED JUST now (and who does not feel a hard-hearted Philistine for gainsaying them?) that we have no right to ostracise, still less to stone, unwholesome kinds of art, make much of the fact that, as we are told in church, "We have no health in us." But it is the recognition of this lack of health which hardens my heart to unwholesome persons and things. If we must be wary of what moods and preferences we foster in ourselves, it is because so few of us are congenitally sound—perhaps none without some organic

weakness; and because, even letting soundness alone, very few of us lead lives that are not, in one respect or another, strained or starved or cramped. Gods and archangels might certainly indulge exclusively in the literature and art for which Baudelaire may stand in this discussion. But gods and archangels require neither filters nor disinfectants, and may slake their thirst in the veriest decoction of typhoid.

VII

THE GREEKS, WHO WERE A fortunate mixture of Conservatives and Anarchists, averred that the desire for the impossible (I do not quote, for, alas! I should not understand the quotation) is a disease of the soul.

It is not, I think, the desire for the impossible (since few can tell what seems impossible, and fewer care for what indubitably is so) so much as the desire for the topsy-turvy. Baudelaire, who admired persons thus afflicted, has a fine line:

"De la réalité grands esprits contempteurs";

but what they despised was not the real, but the usual. Now the usual, of the sort thus despised, happens to represent the necessities of our organisms and of that wider organism which we call circumstances. We may modify it, always in the direction in which it tends spontaneously to evolve; but we cannot subvert it. You might as well try to subvert gravitation: "Je m'en suis aperçu étant par terre," is the only result, as in Molière's lesson of physics.

VIII

ALSO, WHEN YOU COME TO think of it, there is nothing showing a finer organisation in the incapacity for finding sugar sweet and vinegar sour. The only difference is that, as sugar happens to be sweet and vinegar sour, an organisation which perceives the reverse is at sixes and sevens with the universe, or a bit of the universe; and, exactly to the extent to which this six-and-sevenness prevails, is likely to be mulcted of some of the universe's good things.

How may I bring this home, without introducing a sickly atmosphere of decadent art and literature into my valley of the bay-trees? And yet, an instance is needed. Well; there is an old story, originating perhaps

in Suetonius, handed on by Edgar Poe, and repeated, with variations, by various modern French writers, of sundry persons who, among other realities, despise the fact that sheets and table-linen are usually white; and show the subtlety of their organisation (the Emperor Tiberius, a very subtle person, was one of the earliest to apply the notion) by taking their sleep and food in an arrangement of black materials; a sort of mourning warehouse of beds and dining-tables.

Now this means simply that these people have bought "distinction" at the price of one of mankind's most delightful birthrights, the pleasure in white, the queen, as Leonardo put it, of all colours. Our minds, our very sensations are interwoven so intricately of all manner of impressions and associations, that it is no allegory to say that white is good, and that the love of white is akin somehow to the love of virtue. For the love of white has come to mean, thanks to the practice of all centuries and to the very structure of our nerves, strength, cleanness, and newness of sensation, capacity for re-enjoying the already enjoyed, for preferring the already preferred, for discovering new interest and pleasureableness in old things, instead of running to new ones, as one does when not the old ones are exhausted, but one's own poor vigour. The love of white means, furthermore, the appreciation of certain circumstances, delightful and valuable in themselves, without which whiteness cannot be present: in human beings, good health and youth and fairness of life; in houses (oh! the white houses of Cadiz, white between the blue sky and blue sea!), excellence of climate, warmth, dryness and clearness of air; and in all manner of household goods and stuff, care, order, daintiness of habits, leisure and affluence. All things these which, quite as much as any peculiarity of optic function, give for the healthy mind a sort of restfulness, of calm, of virtue, and I might almost say, of regal or priestly quality to white; a quality which suits it to the act of restoring our bodies with food and wine, above all, to the act of spiritual purification, the passing through the cool, colourless, stainless, which constitutes true sleep.

All this the Emperor Tiberius and his imitators forego with their bogey black sheets and table-cloths. . .

IX

BUT WHAT IF WE DO *not care for white*? What if we are so constituted that its insipidity sickens *us* as much as the most poisonous and

putrescent colours which Blake ever mixed to paint hell and sin? Nay, if those grumous and speckly viscosities of evil green, orange, poppy purple, and nameless hues, are the only things which give us any pleasure?

Is it a reason, because you arcadian Optimists of Evolution extract, or imagine you extract, some feeble satisfaction out of white, that we should pretend to enjoy it, and the Antique and Outdoor Nature, and Early Painters, and Mozart and Gluck, and all the whitenesses physical and moral? You say we are abnormal, unwholesome, decaying; very good, then why should we not get pleasure in decaying, unwholesome, and abnormal things? We are like the poison-monger's daughter in Nathaniel Hawthorne's story. Other people's poison is our meat, and we should be killed by an antidote; that is to say, bored to death, which, in our opinion, is very much worse.

To this kind of speech, common since the romantic and pre-Raphaelite movement, and getting commoner with the spread of theories of intellectual anarchy and nervous degeneracy, one is often tempted to answer impatiently, "Get out of the way, you wretched young people; don't you see that there isn't room or time for your posing?"

But unfortunately it is not all pose. There are a certain number of people who really are *bored with white*; for whom, as a result of constitutional morbidness, of nervous exhaustion, or of that very disintegration of soul due to unwholesome æsthetic self-indulgence, to the constant quest for violent artistic emotion, our soul's best food has really become unpalatable and almost nauseous. These people cannot live without spiritual opium or alcohol, although that opium or alcohol is killing them by inches. It is absurd to be impatient with them. All one can do is to let them go in peace to their undoing, and hope that their example will be rather a warning than a model to others.

X

But, letting alone the possibility of art acting as a poison for the soul, there remains an important question. As I said, although art is one of the most wholesome of our soul's activities, there are yet kinds of art, or (since it is a subjective question of profit or damage to ourselves) rather kinds of artistic effect, which, for some evident reason, or through some obscure analogy or hidden point of contact awaken those movements of the fancy, those states of the emotions

which disintegrate rather than renew the soul, and accustom us rather to the yielding and proneness which we shun, than to the resistance and elasticity which we seek throughout life to increase.

I was listening, last night, to some very wonderful singing of modern German songs; and the emotion that still remains faintly within me alongside of the traces of those languishing phrases and passionate intonations, the remembrance of the sense of—how shall I call it?—violation of the privacy of the human soul which haunted me throughout that performance, has brought home to me, for the hundredth time, that the Greek legislators were not so fantastic in considering music a questionable art, which they thought twice before admitting into their ideal commonwealths. For music can do more by our emotions than the other arts, and it can, therefore, separate itself from them and their holy ways; it can, in a measure, actually undo the good they do to our soul.

But, you may object, poetry does the very same; it also expresses, strengthens, brings home our human, momentary, individual emotions, instead of uniting with the arts of visible form, with the harmonious things of nature, to create for us another kind of emotion, the emotion of the eternal, unindividual, universal life, in whose contemplation our souls are healed and made whole after the disintegration inflicted by what is personal and fleeting.

It is true that much poetry expresses merely such personal and momentary emotion; but it does so through a mechanism differing from that of music, and possessing a saving grace which the emotion-compelling mechanism of music does not. For by the very nature of the spoken or written word, by the word's strictly intellectual concomitants, poetry, even while rousing emotion, brings into play what is most different to emotion, emotion's sifter and chastener, the great force which reduces all things to abstraction, to the eternal and typical: reason. You cannot express in words, even the most purely instinctive, half-conscious feeling, without placing that dumb and blind emotion in the lucid, balanced relations which thought has given to words; indeed, words rarely, if ever, reproduce emotion as it is, but instead, emotion as it is instinctively conceived, in its setting of cause and effect. Hence there is in all poetry a certain reasonable element which, even in the heyday of passion, makes us superior to passion by explaining its why and wherefore; and even when the poet succeeds in putting us in the place of him who feels, we enter only into one-half of his personality,

the half which contemplates while the other suffers: we *know* the feeling, rather than *feel* it.

Now, it is different with music. Its relations to our nerves are such that it can reproduce emotion, or, at all events, emotional moods, directly and without any intellectual manipulation. We weep, but know not why. Its specifically artistic emotion, the power it shares with all other arts of raising our state of consciousness to something more complete, more vast, and more permanent—the specific musical emotion of music can become subservient to the mere awakening of our latent emotional possibilities, to the stimulating of emotions often undesirable in themselves, and always unable, at the moment, to find their legitimate channel, whence enervation and perhaps degradation of the soul. There are kinds of music which add the immense charm, the subduing, victorious quality of art, to the power of mere emotion as such; and in these cases we are pushed, by the delightfulness of beauty and wonder, by the fascination of what is finer than ourselves, into deeper consciousness of our innermost, primæval, chaotic self: the stuff in which soul has not yet dawned. We are made to enjoy what we should otherwise dread; and the dignity of beauty, and beauty's frankness and fearlessness, are lent to things such as we regard, under other circumstances, as too intimate, too fleeting, too obscure, too unconscious, to be treated, in ourselves and our neighbours, otherwise than with decorous reserve.

It is astonishing, when one realises it, that the charm of music, the good renown it has gained in its more healthful and more decorous days, can make us sit out what we do sit out under its influence: violations of our innermost secrets, revelations of the hidden possibilities of our own nature and the nature of others; stripping away of all the soul's veils; nay, so to speak, melting away of the soul's outward forms, melting away of the soul's active structure, its bone and muscle, till there is revealed only the shapeless primæval nudity of confused instincts, the soul's vague viscera.

When music does this, it reverts, I think, towards being the nuisance which, before it had acquired the possibilities of form and beauty it now tends to despise, it was felt to be by ancient philosophers and law-givers. At any rate, it sells its artistic birthright. It renounces its possibility of constituting, with the other great arts, a sort of supplementary contemplated nature; an element wherein to buoy up and steady those fluctuations which we express in speech; a vast emotional serenity, an

abstract universe in which our small and fleeting emotions can be transmuted, and wherein they can lose themselves in peacefulness and strength.

XI

I mentioned this one day to my friend the composer. His answer is partly what I was prepared for: this emotionally disintegrating element ceases to exist, or continues to exist only in the very slightest degree, for the real musician. The effect on the nerves is overlooked, neutralised, in the activity of the intellect; much as the emotional effect of the written word is sent into the background by the perception of cause and effect which the logical associations of the word produce. For the composer, even for the performer, says my friend, music has a logic of its own, so strong and subtle as to overpower every other consideration.

But music is not merely for musicians; the vast majority will always receive it not actively through the intellect, but passively through the nerves; the mood will, therefore, be induced before, so to speak, the image, the musical structure, is really appreciated. And, meanwhile, the soul is being made into a sop.

"For the moment," answers my composer, "perhaps; but only for the moment. Once the nerves accustomed to those modulations and rhythms; once the form perceived by the mind, the emotional associations will vanish; the hearer will have become what the musician originally was. . . How do you know that, in its heyday, all music may not have affected people as Wagner's music affects them nowadays? What proof have you got that the strains of Mozart and Gluck, nay, those of Palestrina, which fill our soul with serenity, may not have been full of stress and trouble when they first were heard; may not have laid bare the chaotic elements of our nature, brought to the surface its primæval instincts? Historically, all you know is that Gluck's *Orpheus* made our ancestors weep; and that Wagner's *Tristram* makes our contemporaries sob. . ."

This is the musician's defence. Does it free his art from my rather miserable imputation? I think not. If all this be true, if *Orpheus* has been what *Tristram* is, all one can say is *the more's the pity*. If it be true, all music would require the chastening influence of time, and its spiritual value would be akin to that of the Past and Distant; it would be innocuous, because it had lost half of its vitality. We should have

to lay down music, like wine, for the future; poisoning ourselves with the acrid fumes of its must, the heady, enervating scent of scum and purpled vat, in order that our children might drink vigour and warmth after we were dead.

XII

BUT I DOUBT VERY MUCH whether this is true. It is possible that the music of Wagner may eventually become serene like the music of Handel; but was the music of Handel ever morbid like the music of Wagner?

I do not base my belief on any preference from Handel's contemporaries. We may, as we are constantly being told, be *degenerates*; but there was no special grace whence to degenerate in our perruked forefathers. Moreover, I believe that any very spontaneous art is to a very small degree the product of one or even two or three generations of men. It has been growing to be what it is for centuries and centuries. Its germ and its necessities of organism and development lie far, far back in the soul's world-history; and it is but later, if at all, when the organic growth is at an end, that times and individuals can fashion it in their paltry passing image. No; we may be as strong and as pure as Handel's audiences, and our music yet be less strong and pure than theirs.

My reason for believing in a fundamental emotional difference between that music and ours is of another sort. I think that in art, as in all other things, the simpler, more normal interest comes first, and the more complex, less normal, follows when the simple and normal has become, through familiarity, the insipid. While pleasure unspiced by pain is still a novelty there is no reason thus to spice it.

XIII

THE QUESTION CAN, HOWEVER, BE tolerably settled by turning over the means which enable music to awaken emotion—emotion which we recognise as human, as distinguished from the mere emotion of pleasure attached to all beautiful sights and sounds. Once we have understood what these means are, we can enquire to what extent they are employed in the music of various schools and epochs, and thus judge, with some chance of likelihood, whether the music which strikes us as serene and vigorous could have affected our ancestors as turbid and enervating.

'Tis a dull enough psychological examination; but one worth making, not merely for the sake of music itself, but because music, being the most emotional of all the arts, can serve to typify the good or mischief which all art may do, according to which of our emotions it fosters.

'TIS REPEATING A FACT IN different words, not stating anything new, to say that all beautiful things awaken a specific sort of emotion, the emotion or the mood of the beautiful. Yet this statement, equivalent to saying that hot objects give us the sensation of heat, and wet objects the sensation of wetness, is well worth repeating, because we so often forget that the fact of beauty in anything is merely the fact of that thing setting up in ourselves a very specific feeling.

Now, BESIDES THIS BEAUTY OR quality producing the emotion of the beautiful, there exist in things a lot of other qualities also producing emotion, each according to its kind; or rather, the beautiful thing may also be qualified in some other way, as the thing which is useful, useless, old, young, common, rare, or whatever you choose. And this coincidence of qualities produces a coincidence of states of mind. We shall experience the feeling not merely of beauty because the thing is beautiful, but also of surprise because it is startling, of familiarity because we meet it often, of attraction (independently of beauty) because the thing suits or benefits us, or of repulsion (despite the beauty) because the thing has done us a bad turn or might do us one. This is saying that beauty is only one of various relations possible between something not ourselves and our feelings, and that it is probable that other relations between them may exist at the same moment, in the same way that a woman may be a man's wife, but also his cousin, his countrywoman, his school-board representative, his landlady, and his teacher of Latin, without one qualification precluding the others.

Now, in the arts of line, colour, and projection, the arts which usually copy the appearance of objects existing outside the art, these other qualities, these other relations between ourselves and the object which exists in the relation of beauty, are largely a matter of superficial association—I mean, of association which may vary, and of which we are most often conscious.

We are reminded by the picture or statue of qualities which do not exist in it, but in its prototype in reality. A certain face will awaken disgust when seen in a picture, or reverence or amusement, besides

the specific impression of beauty (or its reverse), because we have experienced disgust, awe, amusement in connection with a similar face outside the picture.

So far, therefore, as art is imitative, its non-artistic emotional capacities are due (with a very few exceptions) to association; for the feelings traceable directly to fatigue or disintegration of the perceptive faculty usually, indeed almost always, prevent the object from affecting us as beautiful. It is quite otherwise when we come to music. Here the coincidence of other emotion resides, I believe, not in the *musical thing itself*, not in the musician's creation without prototype in reality, resembling nothing save other musical structures; the coincidence resides in the elements out of which that structure is made, and which, for all its complexities, are still very strongly perceived by our senses. For instance, certain rhythms existing in music are identical with, or analogous to, the rhythm of our bodily movements under varying circumstances: we know alternations of long and short, variously composed regularities and irregularities of movement, fluctuations, reinforcements or subsidences, from experience other than that of music; we know them in connection with walking, jumping, dragging; with beating of heart and arteries, expansion of throat and lungs; we knew them, long before music was, as connected with energy or oppression, sickness or health, elation or depression, grief, fear, horror, or serenity and happiness. And when they become elements of a musical structure their associations come along with them. And these associations are the more powerful that, while they are rudimentary, familiar like our own being, perhaps even racial, the musical structure into which they enter is complete, individual, *new*: 'tis comparing the efficacy of, say, Mozart Op. So-and-so, with the efficacy of somebody sobbing or dancing in our presence.

So far for the associational power of music in awakening emotions. But music has another source of such power over us. Existing as it does in a sequence, it is able to give sensations which the arts dealing with space, and not with time, could not allow themselves, since for them a disagreeable effect could never prelude an agreeable one, but merely co-exist with it; whereas for music a disagreeable effect is effaceable by an agreeable one, and will even considerably heighten the latter by being made to precede it. Now we not merely associate fatigue or pain with any difficult perception, we actually feel it; we are aware of real discomfort whenever our senses and attention are kept too long on the stretch, or are stimulated too sharply by something unexpected.

In these cases we are conscious of something which is exhausting, overpowering, unendurable if it lasted: experiences which are but too familiar in matters not musical, and, therefore, evoke the remembrance of such non-musical discomfort, which reacts to increase the discomfort produced by the music; the reverse taking place, a sense of freedom, of efficiency, of strength arising in us whenever the object of perception can be easily, though energetically, perceived. Hence intervals which the ear has difficulty in following, dissonances to which it is unaccustomed, and phrases too long or too slack for convenient scansion, produce a degree of sensuous and intellectual distress, which can be measured by the immense relief—relief as an acute satisfaction—of return to easier intervals, of consonance, and of phrases of normal rhythm and length.

Thus does it come to pass that music can convey emotional suggestions such as painting and sculpture, for all their imitations of reality, can never match in efficacy; since music conveys the suggestions not of mere objects which may have awakened emotion, but of emotion itself, of the expression thereof in our bodily feelings and movements. And hence also the curious paradox that musical emotion is strong almost in proportion as it is vague. A visible object may, and probably will, possess a dozen different emotional values, according to our altering relations therewith; for one relation, one mood, one emotion succeeds and obliterates the other, till nothing very potent can remain connected with that particular object. But it matters not how different the course of the various emotions which have expressed themselves in movements of slackness, agitation, energy, or confusion; it matters not through what circumstances our vigour may have leaked away, our nerves have been harrowed, our attention worn out, so long as those movements, those agitations, slackenings, oppressions, reliefs, fatigues, harrowings, and reposings are actually taking place within us. In briefer phrase, while painting and sculpture present us only with objects possibly connected with emotions, but probably connected with emotions too often varied to affect us strongly; music gives us the actual bodily consciousness of emotion; nay (in so far as it calls for easy or difficult acts of perception), the actual mental reality of comfort or discomfort.

XIV

THE EMOTION UPPERMOST IN THE music of all these old people is the specific emotion of the beautiful; the emotional possibilities,

latent in so many elements of the musical structure, never do more than qualify the overwhelming impression due to that structure itself. The music of Handel and Bach is beautiful, with a touch of awe; that of Gluck, with a tinge of sadness; Mozart's and his contemporaries' is beautiful, with a reminiscence of all tender and happy emotions; then again, there are the great Italians of the seventeenth and eighteenth centuries, Carissimi, Scarlatti the elder, Marcello, whose musical beauty is oddly emphasised with energy and sternness, due to their powerful, simple rhythms and straightforward wide intervals. But whatever the emotional qualification, the chief, the never varying, all-important characteristic, is the beauty; the dominant emotion is the serene happiness which beauty gives: happiness, strong and delicate; increase of our vitality; evocation of all cognate beauty, physical and moral, bringing back to our consciousness all that which is at once wholesome and rare. For beauty such as this is both desirable and, in a sense, far-fetched; it comes naturally to us, and we meet it half-way; but it does not come often enough.

Hence it is that the music of these masters never admits us into the presence of such feelings as either were better not felt, or at all events, not idly witnessed. There is not ever anything in the joy or grief suggested by this music, in the love of which it is an expression, which should make us feel abashed in feeling or witnessing. The whole world may watch *Orpheus* or *Alcestis*, as the whole world may stand (with Bach or Pergolese to make music) at the foot of the Cross. But may the whole world sit idly watching the raptures and death-throes of Tristram and Yseult?

Surely the world has grown strangely intrusive and unblushing.

XV

I HAVE SPOKEN OF THIS old music as an expression of love; and this, in the face of the emotional effects of certain modern composers, may make some persons smile.

Perhaps I should rather have said that this old music expresses, above everything else, the *lovable*; for does not eminent beauty inevitably awaken love, either as respect or tenderness; the lovable, *loveliness*? And at the same time the love itself such loveliness awakens. Love far beyond particular cases or persons, fitting all noble things, real and imaginary, complex or fragmentary. Love as a lyric essence.

XVI

But why not more than merely that? I used at one time to have frequent discussions on art and life with a certain poor friend of mine, who should have found sweetness in both, giving both sweetness in return, but, alas, did neither. We were sitting in the fields where the frost-bitten green was just beginning to soften into minute starlike buds and mosses, and the birds were learning to sing in the leafless lilac hedgerows, the sunshine, as it does in spring, seeming to hold the world rather than merely to pour on to it. "You see," said my friend, "you see, there is a fundamental difference between us. You are satisfied with what you call *happiness*; but I want *rapture and excess*."

Alas, a few years later, the chance of happiness had gone. That door was opened, of which Epictetus wrote that we might always pass through it; in this case not because "the room was too full of smoke," but, what is sadder by far, because the room was merely whitewashed and cleanly swept.

But those words "rapture and excess," spoken in such childlike simplicity of spirit, have always remained in my mind. Should we not teach our children, among whom there may be such as that one was, that the best thing life can give is just that despised thing *happiness*?

XVII

Now art, to my mind, should be one of our main sources of happiness; and under the inappropriate word *art*, I am obliged, as usual, to group all such activities of soul as deal with beauty, quite as much when it exists in what is (in this sense) not art's antithesis, but art's origin and completion, nature. Nay, art—the art exercised by the craftsman, but much more so the art, the selecting, grouping process performed by our own feelings—art can do more towards our happiness than increase the number of its constituent items: it can mould our preferences, can make our souls more resisting and flexible, teach them to keep pace with the universal rhythm.

Now, there is not room enough in the world, and not stuff enough in us, for much rapture, or for any excess. The space, as it were, the material which these occupy and exhaust, has to be paid for; rapture is paid for by subsequent stinting, and excess by subsequent bankruptcy.

We all know this in even trifling matters; the dulness, the lassitude

or restlessness, the incapacity for enjoyment following any very acute or exciting pleasure. A man after a dangerous ride, a girl after her first wildly successful ball, are not merely exhausted in body and in mind; they are momentarily deprived of the enjoyment of slighter emotions; 'tis like the inability to hear one's own voice after listening to a tremendous band.

The gods, one might say in Goethian phrase, did not intend us to share their own manner of being; or, if you prefer it, in the language of Darwin or Weissmann, creatures who died of sheer bliss, were unable to rear a family and to found a species. Be it as it may, rapture must needs be rare, because it destroys a piece of us (makes our precious piece of chagrin skin, as in Balzac's story, shrink each time). And, as we have seen, it destroys (which is more important than destruction of mere life) our sensibility to those diffuse, long-drawn, gentle, restorative pleasures which are not merely durable, but, because they invigorate our spirit, are actually reproductive of themselves, multiplying, like all sane desirable things, like grain and fruit, ten-fold. Pleasures which I would rather call, but for the cumbersome words, items of happiness. It is therefore no humiliating circumstance if art and beauty should be unable to excite us like a game of cards, a steeplechase, a fight, or some violent excitement of our senses or our vanity. This inability, on the contrary, constitutes our chief reason for considering our pleasure in beautiful sights, sounds, and thoughts, as in a sense, holy.

XVIII

YESTERDAY MORNING, RIDING TOWARDS THE cypress woods, I had the first impression of spring; and, in fact, today the first almond-tree had come out in blossom on our hillside.

A cool morning; loose, quickly moving clouds, and every now and then a gust of rain swept down from the mountains. The path followed a brook, descending in long, steep steps from the hillside; water perfectly clear, bubbling along the yellow stones between the grassy banks and making now and then a little leap into a lower basin; along the stream great screens of reeds, sere, pale, with barely a pennon of leaves, rustling ready for the sickle; and behind, beneath the watery sky, rainy but somehow peaceful, the russet oak-scrub of the hill. Of spring there was indeed visible only the green of the young wheat beneath the olives; not

a bud as yet had moved. And still, it is spring. The world is renewing itself. One feels it in the gusts of cool, wet wind, the songs of the reeds, the bubble of the brook; one feels it, above all, in oneself. All things are braced, elastic, ready for life.

The Art and the Country

Tuscan Notes

" . . . all these are inhabitants of truly mountain cities, Florence being
as completely among the hills as Innsbruck is, only the hills have softer
outlines."

—*Modern Painters*, iv, chap. xx

I

SITTING IN THE JANUARY SUNSHINE on the side of this Fiesole hill,
overlooking the opposite quarries (a few long-stalked daisies at my feet in
the gravel, still soft from the night's frost), my thoughts took the colour
and breath of the place. They circled, as these paths circle round the hill,
about those ancient Greek and old Italian cities, where the cyclopean
walls, the carefully-terraced olives, followed the tracks made first by the
shepherd's and the goat's foot, even as we see them now on the stony
hills all round. What civilisations were those, thus sowed on the rock
like the wild mint and grey myrrh-scented herbs, and grown under the
scorch of sun upon stone, and the eddy of winds down the valleys! They
are gone, disappeared, and their existence would be impossible in our
days. But they have left us their art, the essence they distilled from their
surroundings. And that is as good for our souls as the sunshine and the
wind, as the aromatic scent of the herbs of their mountains.

II

I AM TEMPTED TO THINK that the worst place for getting to know,
getting to *feel*, any school of painting, is the gallery, and the best,
perhaps, the fields: the fields (or in the case of the Venetians, largely the
waters), to which, with their qualities of air, of light, their whole train of
sensations and moods, the artistic temperament, and the special artistic
temperament of a local school, can very probably be traced.

For to appreciate any kind of art means, after all, not to understand
its relations with other kinds of art, but to feel its relations with
ourselves. It is a matter of living, thanks to that art, according to the

spiritual and organic modes of which it is an expression. Now, to go from room to room of a gallery, allowing oneself to be played upon by very various kinds of art, is to prevent the formation of any definite mood, and to set up what is most hostile to all mood, to all unity of being: comparison, analysis, classification. You may know quite exactly the difference between Giotto and Simon Martini, between a Ferrarese and a Venetian, between Praxiteles and Scopas; and yet be ignorant of the meaning which any of these might have in your life, and unconscious of the changes they might work in your being. And this, I fear, is often the case with connoisseurs and archæologists, accounting for the latent suspicion of the ignoramus and the good philistine, that such persons are somehow none the better for their intercourse with art.

All art which is organic, short of which it cannot be efficient, depends upon tradition. To say so sounds a truism, because we rarely realise all that tradition implies: on the side of the artist, *what to do*, and on the side of his public, *how to feel*: a habit, an expectation which accumulates the results of individual creative genius and individual appreciative sensibility, giving to each its greatest efficacy. When one remembers, in individual instances—Kant, Darwin, Michel Angelo, Mozart—how very little which is absolutely new, how slight a variation, how inevitable a combination, marks, after all, the greatest strokes of genius in all things, it seems quite laughable to expect the mediocre person, mere looker-on or listener, far from creative, to reach at once, without a similar sequence of initiation, a corresponding state of understanding and enjoyment. But, as a rule, this thought does not occur to us; and, while we expatiate on the creative originality of artists and poets, we dully take for granted the instant appreciation of their creation; forgetting, or not understanding, in both cases, the wonderful efficacy of tradition.

As regards us moderns, for whom the tradition of, say, Tuscan art has so long been broken off or crossed by various other and very different ones—as regards ourselves, I am inclined to think that we can best recover it by sympathetic attention to those forms of art, humbler or more public, which must originally have prepared and kept up the interest of the people for whom the Tuscan craftsmen worked.

Pictures and statues, even in a traditional period, embody a large amount of merely personal peculiarities of individual artists, testifying to many activities—imitation, self-assertion, rivalry—which have no

real æsthetic value. And, during the fifteenth century and in Tuscany especially, the flow of traditional æsthetic feeling is grievously altered and adulterated by the merest scientific tendencies: a painter or sculptor being often, in the first instance, a student of anatomy, archæology or perspective. One may, therefore, be familiar for twenty years with Tuscan Renaissance painting or sculpture, and yet remain very faintly conscious of the special æsthetic character, the *virtues* (in the language of herbals) of Tuscan art. Hence I should almost say, better let alone the pictures and statues until you are sufficiently acquainted with the particular quality lurking therein to recognise, extricate and assimilate it, despite irrelevant ingredients. Learn the *quality* of Tuscan art from those categories of it which are most impersonal, most traditional, and most organic and also freer from scientific interference, say architecture and decoration; and from architecture rather in its humble, unobtrusive work than in the great exceptional creations which imply, like the cupola of Florence, the assertion of a personality, the surmounting of a difficulty, and even the braving of other folks' opinion. I believe that if one learned, not merely to know, but to feel, to enjoy very completely and very specifically, the quality of distinctness and reserve, slightness of means and greatness of proportions, of the domestic architecture and decoration of the fifteenth century, if one made one's own the mood underlying the special straight lines and curves, the symmetry and hiatus of the colonnades, for instance, inside Florentine houses; of the little bits of carving on escutcheon and fireplace of Tuscan hillside farms; let alone of the plainest sepulchral slabs in Santa Croce, one would be in better case for really appreciating, say, Botticelli or Pier della Francesca than after ever so much comparison of their work with that of other painters. For, through familiarity with that humbler, more purely impersonal and traditional art, a certain mode of being in oneself, which is the special æsthetic mood of the Tuscan's would have become organised and be aroused at the slightest indication of the qualities producing it, so that their presence would never escape one. This, I believe, is the secret of all æsthetic training: the growing accustomed, as it were automatically, to respond to the work of art's bidding; to march or dance to Apollo's harping with the irresistible instinct with which the rats and the children followed the pied piper's pipe. This is the æsthetic training which quite unconsciously and incidentally came to the men of the past through daily habit of artistic forms which existed and varied in the commonest objects just as in the greatest masterpieces. And

through it alone was the highest art brought into fruitful contact with even the most everyday persons: the tradition which already existed making inevitable the tradition which followed.

But to return to us moderns, who have to reconstitute deliberately a vanished æsthetic tradition, it seems to me that such familiarity with Tuscan art once initiated, we can learn more, producing and canalising its special moods, from a frosty afternoon like this one on the hillside, with its particular taste of air, its particular line of shelving rock and twisting road and accentuating reed or cypress in the delicate light, than from hours in a room where Signorelli and Lippi, Angelico and Pollaiolo, are all telling one different things in different languages.

III

THESE THOUGHTS, AND THE ONES I shall try to make clear as I go on, began to take shape one early winter morning some ten years ago, while I was staying among the vineyards in the little range of hills which separate the valley of the Ombrone from the lower valley of the Arno. Stony hills, stony paths between leafless lilac hedges, stony outlines of crest, fringed with thin rosy bare trees; here and there a few bright green pines; for the rest, olives and sulphur-yellow sere vines among them; the wide valley all a pale blue wash, and Monte Morello opposite wrapped in mists. It was visibly snowing on the great Apennines, and suddenly, though very gently, it began to snow here also, wrapping the blue distance, the yellow vineyards, in thin veils. Brisk cold. At the house, when I returned from my walk, the children were flattened against the window-panes, shouting for joy at the snow. We grown-up folk, did we live wiser lives, might be equally delighted by similar shows.

A very Tuscan, or rather (what I mean when I make use of that word, for geographically Tuscany is very large and various) a very Florentine day. Beauty, exquisiteness, serenity; but not without austerity carried to a distinct bitingness. And this is the quality which we find again in all very characteristic Tuscan art. Such a country as this, scorched in summer, wind-swept in winter, and constantly stony and uphill, a country of eminently dry, clear, moving air, puts us into a braced, active, self-restrained mood; there is in it, as in these frosty days which suit it best, something which gives life and demands it: a quality of happy effort. The art produced by people in whom such a condition of being

is frequent, must necessarily reproduce this same condition of being in others.

Therefore the connection between a country and its art must be sought mainly in the fact that all art expresses a given state of being, of emotion, not human necessarily, but vital; that is to say, expresses not whether we love or hate, but rather *how* we love or hate, how we *are*. The mountain forms, colour, water, etc., of a country are incorporated into its art less as that art's object of representation, than as the determinant of a given mode of vitality in the artist. Hence music and literature, although never actually reproducing any part of them, may be strongly affected by their character. The *Vita Nuova*, the really great (not merely historically interesting) passages of the Divine Comedy, and the popular songs of Tigri's collection, are as much the outcome of these Tuscan mountains and hills, as is any picture in which we recognise their outlines and colours. Indeed, it happens that of literal rendering (as distinguished from ever-present reference to quality of air or light, to climbing, to rock and stone as such) there is little in the *Commedia*, none at all in either the old or the more modern lyrics, and not so much even in painted landscape. The Tuscan backgrounds of the fifteenth century are *not* these stony places, sun-burnt or wind-swept; they are the green lawns and pastures in vogue with the whole international Middle Ages, but rendered with that braced, selecting, finishing temper which *is* the product of those stony hills. Similarly the Tuscans must have been influenced by the grace, the sparseness, the serenity of the olive, its inexhaustible vigour and variety; yet how many of them ever painted it? That a people should never paint or describe their landscape may mean that they have not consciously inventoried the items; but it does not mean that they have not æsthetically, so to speak *nervously*, felt them. Their quality, their virtue, may be translated into that people's way of talking of or painting quite different things: the Tuscan quality is a quality of form, because it is a quality of mood.

IV

THIS TUSCAN, AND MORE THAN Attic, quality—for there is something akin to it in certain Greek archaic sculpture—is to be found, already perfect and most essential, in the façades of the early mediæval churches of Pistoia. *Is to be found*; because this quality, tense and restrained and distributed with harmonious evenness, reveals

itself only to a certain fineness and carefulness of looking. The little churches (there are four or five of them) belong to the style called Pisan-Romanesque; and their fronts, carved arches, capitals, lintels, and doorposts, are identical in plan, in all that the mind rapidly inventories, with the fronts of the numerous contemporary churches of Lucca. But a comparison with these will bring out most vividly the special quality of the Pistoia churches. The Lucchese ones (of some of which, before their restoration, Mr. Ruskin has left some marvellous coloured drawings at Oxford) run to picturesqueness and even something more; they do better in the picture than in the reality, and weathering and defacement has done much for them. Whereas the little churches at Pistoia, with less projection, less carving in the round, few or no animal or clearly floral forms, and, as a rule, pilasters or half-pillars instead of columns, must have been as perfect the day they were finished; the subtle balancings and tensions of lines and curves, the delicate fretting and inlaying of flat surface pattern, having gained only, perhaps, in being drawn more clearly by dust and damp upon a softer colour of marble. I have mentioned these first, because their apparent insignificance—tiny flat façades, with very little decoration—makes it in a way easier to grasp the special delicate austerity of their beauty. But they are humble offshoots, naturally, of two great and complex masterpieces, and very modest sisters of a masterpiece only a degree less marvellous: Pisa Cathedral, the Baptistery of Florence and San Miniato. The wonderful nature of the most perfect of these three buildings (and yet I hesitate to call it so, remembering the apse and lateral gables of Pisa) can be the better understood that, standing before the Baptistery of Florence, one has by its side Giotto's very beautiful belfry. Looking at them turn about, one finds that the Gothic boldness of light and shade of the Campanile makes the windows, pillars and cornices of the Baptistery seem at first very flat and uninteresting. But after the first time, and once that sense of flatness overcome, it is impossible to revert to the belfry with the same satisfaction. The eye and mind return to the greater perfection of the Baptistery; by an odd paradox there is deeper feeling in those apparently so slight and superficial carvings, those lintels and fluted columns of green marble which scarcely cast a shadow on their ivory-tinted wall. The Tuscan quality of these buildings is the better appreciated when we take in the fact that their architectural items had long existed, not merely in the Romanesque, but in the Byzantine and late Roman. The series of temple-shaped windows on the outside

of the Florence Baptistery and of San Miniato, has, for instance, its original in the Baptistery of Ravenna and the arch at Verona. What the Tuscans have done is to perfect the inner and subtler proportions, to restrain and accentuate, to phrase (in musical language) every detail of execution. By an accident of artistic evolution, this style of architecture, rather dully elaborated by a worn-out civilisation, has had to wait six centuries for life to be put into it by a finer-strung people at a chaster and more braced period of history. Nor should we be satisfied with such loose phrases as this, leading one to think, in a slovenly fashion (quite unsuitable to Tuscan artistic lucidity), that the difference lay in some vague metaphysical entity called *spirit*: the spirit of the Tuscan stonemasons of the early Middle Ages altered the actual tangible forms in their proportions and details: this spiritual quality affects us in their carved and inlaid marbles, their fluted pilasters and undercut capitals, as a result of actual work of eye and of chisel: they altered the expression by altering the stone, even as the frosts and August suns and trickling water had determined the expression, by altering the actual surface, of their lovely austere hills.

V

THE TUSCAN QUALITY IN ARCHITECTURE must not be sought for during the hundred years of Gothic—that is to say, of foreign—supremacy and interregnum. The stonemasons of Pisa and of Florence did indeed apply their wholly classic instincts to the detail and ornament of this alien style; and one is struck by the delicacy and self-restraint of, say, the Tuscan ones among the Scaliger tombs compared with the more picturesque looseness of genuine Veronese and Venetian Gothic sculpture. But the constructive, and, so to speak, space enclosing, principles of the great art of mediæval France were even less understood by the Tuscan than by any other Italian builders; and, as the finest work of Tuscan façade architecture was given before the Gothic interregnum, so also its most noble work, as actual spatial arrangement, must be sought for after the return to the round arch, the cupola and the entablature of genuine Southern building. And then, by a fortunate coincidence (perhaps because this style affords no real unity to vast naves and transepts), the architectural masterpieces of the fifteenth century are all of them (excepting, naturally, Brunelleschi's dome) very small buildings: the Sacristies of S. Lorenzo and S. Spirito, the chapel

of the Pazzi, and the late, but exquisite, small church of the Carceri at Prato. The smallness of these places is fortunate, because it leaves no doubt that the sense of spaciousness—of our being, as it were, enclosed with a great part of world and sky around us—is an artistic illusion got by co-ordination of detail, greatness of proportions, and, most of all, perhaps, by quite marvellous distribution of light. These small squares, or octagons, most often with a square embrasure for the altar, seem ample habitations for the greatest things; one would wish to use them for Palestrina's music, or Bach's, or Handel's; and then one recognises that their actual dimensions in yards would not accommodate the band and singers and the organ! Such music must remain in our soul, where, in reality, the genius of those Florentine architects has contrived the satisfying ampleness of their buildings.

That they invented nothing in the way of architectural ornament, nay, took their capitals, flutings, cornices, and so forth, most mechanically from the worst antique, should be no real drawback to this architecture; it was, most likely, a matter of negative instinct. For these meagre details leave the mind free, nay, force it rather, to soar at once into the vaultings, into the serene middle space opposite the windows, and up into the enclosed heaven of the cupolas.

VI

THE TUSCAN SCULPTURE OF THIS period stands, I think, midway between the serene perfection of the buildings (being itself sprung from the architecture of the Gothic time), and the splendid but fragmentary accomplishment of the paintings, many of whose disturbing problems, of anatomy and anatomic movement, it shared to its confusion. It is not for beautiful bodily structure or gesture, such as we find even in poor antiques, that we should go to the Florentine sculptors, save, perhaps, the two Robbias. It is the almost architectural distribution of space and light, the treatment of masses, which makes the immeasurable greatness of Donatello, and gives dignity to his greatest contemporary, Jacopo della Quercia. And it is again an architectural quality, though in the sense of the carved portals of Pistoia, the flutings and fretwork and surface pattern of the Baptistery and S. Miniato, which gives such poignant pleasure in the work of a very different, but very great, sculptor, Desiderio. The marvel (for it is a marvel) of his great monument in Santa Croce, depends not on

anatomic forms, but on the exquisite variety and vivacity of surface arrangement; the word symphony (so often misapplied) fitting exactly this complex structure of minute melodies and harmonies of rhythms and accents in stone.

But the quality of Tuscan sculpture exists in humbler, often anonymous and infinitely pathetic work. I mean those effigies of knights and burghers, coats of arms and mere inscriptions, which constitute so large a portion of what we walk upon in Santa Croce. Things not much thought of, maybe, and ruthlessly defaced by all posterity. But the masses, the main lines, were originally noble, and defacement has only made their nobleness and tenderness more evident and poignant: they have come to partake of the special solemnity of stone worn by frost and sunshine.

VII

THERE ARE A GREAT MANY items which go to make up Tuscany and the specially Tuscan mood. The country is at once hilly and mountainous, but rich in alluvial river valleys, as flat and as wide, very often, as plains; and the chains which divide and which bound it are as various as can be: the crystalline crags of Carrara, the washed away cones and escarpments of the high Apennines, repeating themselves in counter forts and foothills, and the low, closely packed ridges of the hills between Florence and Siena. Hence there is always a view, definite and yet very complex, made up of every variety of line, but always of clearest perspective: perfect horizontals at one's feet, perfect perpendiculars opposite the eye, a constant alternation of looking up and looking down, a never-failing possibility of looking *beyond*, an outlet everywhere for the eye, and for the breath; and endless intricacy of projecting spur and engulfed ravine, of valley above valley, and ridge beyond ridge; and all of it, whether definitely modelled by stormy lights or windy dryness, or washed to mere outline by sunshine or mist, always massed into intelligible, harmonious, and ever-changing groups. Ever changing as you move, hills rising or sinking as you mount or descend, furling or unfurling as you go to the right or to the left, valleys and ravines opening or closing up, the whole country altering, so to speak, its attitude and gesture as quickly almost, and with quite as perfect consecutiveness, as does a great cathedral when you walk round it. And, for this reason, never letting you rest; keeping *you* also in movement, feet,

eyes and fancy. Add to all this a particular topographical feeling, very strong and delightful, which I can only describe as that of seeing all the kingdoms of the earth. In the high places close to Florence (and with that especial lie of the land everything is a *high place*) a view is not only of foregrounds and backgrounds, river troughs and mountain lines of great variety, but of whole districts, or at least indications of districts— distant peaks making you feel the places at their feet—which you know to be extremely various: think of the Carraras with their Mediterranean seaboard, the high Apennines with Lombardy and the Adriatic behind them, the Siena and Volterra hills leading to the Maremma, and the great range of the Falterona, with the Tiber issuing from it, leading the mind through Umbria to Rome!

The imagination is as active among these Florentine hills as is the eye, or as the feet and lungs have been, pleasantly tired, delighting in the moment's rest, after climbing those steep places among the pines or the myrtles, under the scorch of the wholesome summer sun, or in the face of the pure, snowy wind. The wind, so rarely at rest, has helped to make the Tuscan spirit, calling for a certain resoluteness to resist it, but, in return, taking all sense of weight away, making the body merge, so to speak, into eye and mind, and turning one, for a little while, into part of the merely visible and audible. The frequent possibility of such views as I have tried to define, of such moments of fulness of life, has given, methinks, the quality of definiteness and harmony, of active, participated in, greatness, to the art of Tuscany.

VIII

IT IS A PITY THAT, as regards painting, this Tuscan feeling (for Giottesque painting had the cosmopolitan, as distinguished from local, quality of the Middle Ages and of the Franciscan movement) should have been at its strongest just in the century when mere scientific interest was uppermost. Nay, one is tempted to think that matters were made worse by that very love of the strenuous, the definite, the lucid, which is part of the Tuscan spirit. So that we have to pick out, in men like Donatello, Uccello, Pollaiolo and Verrocchio, nay, even in Lippi and Botticelli, the fragments which correspond to what we get quite unmixed and perfect in the Romanesque churches of Pisa, Florence, and Pistoia, in the sacristies and chapels of Brunelleschi, Alberti, and Sangallo, and in a hundred exquisite cloisters and loggias of unnoticed

town houses and remote farms. But perhaps there is added a zest (by no means out of keeping with the Tuscan feeling) to our enjoyment by the slight effort which is thus imposed upon us: Tuscan art does not give its exquisiteness for nothing.

Be this as it may, the beauty of Florentine Renaissance painting must be sought, very often, not in the object which the picture represents, but in the mode in which that object is represented. Our habits of thought are so slovenly in these matters, and our vocabulary so poor and confused, that I find it difficult to make my exact meaning clear without some insistence. I am not referring to the mere moral qualities of care, decision, or respectfulness, though the recognition thereof adds undoubtedly to the noble pleasure of a work of art; still less to the technical or scientific lucidity which the picture exhibits. The beauty of fifteenth-century painting is a visible quality, a quality of the distribution of masses, the arrangement of space; above all, of the lines of a picture. But it is independent of the fact of the object represented being or not what in real life we should judge beautiful; and it is, in large works, unfortunately even more separate from such arrangement as will render a complicated composition intelligible to the mind or even to the eye. The problems of anatomy, relief, muscular action, and perspective which engrossed and in many cases harassed the Florentines of the Renaissance, turned their attention away from the habit of beautiful general composition which had become traditional even in the dullest and most effete of their Giottesque predecessors, and left them neither time nor inclination for wonderful new invention in figure distribution like that of their contemporary Umbrians. Save in easel pictures, therefore, there is often a distressing confusion, a sort of dreary random packing, in the works of men like Uccello, Lippi, Pollaiolo, Filippino, Ghirlandaio, and even Botticelli. And even in the more simply and often charmingly arranged easel pictures, the men and women represented, even the angels and children, are often very far from being what in real life would be deemed beautiful, or remarkable by any special beauty of attitude and gesture. They are, in truth, studies, anatomical or otherwise, although studies in nearly every case dignified by the habit of a very serious and tender devoutness: rarely soulless or insolent studio drudgery or swagger such as came when art ceased to be truly popular and religious. Studies, however, with little or no selection of the reality studied, and less thought even for the place or manner in which they were to be used.

But these studies are executed, however scientific their intention, under the guidance of a sense and a habit of beauty, subtle and imperious in proportion, almost, as it is self-unconscious. These figures, sometimes ungainly, occasionally ill-made, and these features, frequently homely or marred by some conspicuous ugliness, are made up of lines as enchantingly beautiful, as seriously satisfying, as those which surrounded the Tuscans in their landscape. And it is in the extracting of such beauty of lines out of the bewildering confusion of huge frescoes, it is in the seeing as arrangements of such lines the sometimes unattractive men and women and children painted (and for that matter, often also sculptured) by the great Florentines of the fifteenth century, that consists the true appreciation and habitual enjoyment of Tuscan Renaissance painting. The outline of an ear and muscle of the neck by Lippi; the throw of drapery by Ghirlandaio; the wide and smoke-like rings of heavy hair by Botticelli; the intenser, more ardent spiral curls of Verrocchio or the young Leonardo; all that is flower-like, flame-like, that has the swirl of mountain rivers, the ripple of rocky brooks, the solemn and poignant long curves and sudden crests of hills, all this exists in the paintings of the Florentines; and it is its intrinsic nobility and exquisiteness, its reminiscence and suggestion of all that is loveliest and most solemn in nature, its analogy to all that is strongest and most delicate in human emotion, which we should seek for and cherish in their works.

IX

THE HOUR OF LOW LIGHTS, which the painters of the past almost exclusively reproduced, is naturally that in which we recognise easiest, not only the identity of mood awakened by the art and by the country, but the closer resemblance between the things which art was able to do, and the things which the country had already done. Even more, immediately after sunset. The hills, becoming uniform masses, assert their movement, strike deep into the valley, draw themselves strongly up towards the sky. The valleys also, with their purple darkness, rising like smoke out of them, assert themselves in their turn. And the sky, the more diaphanous for all this dark solidity against it, becomes sky more decisively; takes, moreover, colour which only fluid things can have; turns into washes of pale gold, of palest tea-rose pink and beryl green. Against this sky the cypresses are delicately finished off

in fine black lacework, even as in the background of Botticelli's *Spring*, and Leonardo's or Verrocchio's *Annuniciation*. One understands that those passionate lovers of line loved the moment of sunset apart even from colour. The ridges of pines and cypresses soon remain the only distinguishable thing in the valleys, pulling themselves (as one feels it) rapidly up, like great prehistoric shapes of Saurians. Soon the sky only and mountains will exist. Then begins the time, before the starlit night comes to say its say, when everything grows drowsy, a little vague, and the blurred mountains go to sleep in the smoke of dusk. Then only, due west, the great Carrara peaks stand out against the sanguine sky, long pointed curves and flame-shaped sudden crests, clear and keen beyond the power of mortal hand to draw.

X

THE QUALITY OF SUCH SIGHTS as these, as I have more than once repeated, requires to be diligently sought for, and extricated from many things which overlay or mar it, throughout nearly the whole of Florentine Renaissance painting. But by good luck there is one painter in whom we can enjoy it as subtle, but also as simple, as in the hills and mountains outlined by sunset or gathered into diaphanous folds by the subduing radiance of winter moon. I am speaking, of course, of Pier della Francesca; although an over literal school of criticism stickles at classing him with the other great Florentines. Nay, by a happy irony of things, the reasons for this exclusion are probably those to which we owe the very purity and perfection of this man's Tuscan quality. For the remoteness of his home on the southernmost border of Tuscany, and in a river valley—that of the Upper Tiber—leading away from Florence and into Umbria, may have kept him safe from that scientific rivalry, that worry and vexation of professional problems, which told so badly on so many Florentine craftsmen. And, on the other hand, the north Italian origin of one of his masters, the mysterious Domenico Veneziano, seems to have given him, instead of the colouring, always random and often coarse, of contemporary Florence, a harmonious scheme of perfectly delicate, clear, and flower-like colour. These two advantages are so distinctive that, by breaking through the habits one necessarily gets into with his Florentine contemporaries, they have resulted in setting apart, and almost outside the pale of Tuscan painting, the purest of all Tuscan artists. For with him there is no

need for making allowances or disentangling essentials. The vivid organic line need not be sought in details nor, so to speak, abstracted: it bounds his figures, forms them quite naturally and simply, and is therefore not thought about apart from them. And the colour, integral as it is, and perfectly harmonious, masses the figures into balanced groups, bossiness and bulk, detail and depth, all unified, co-ordinated, satisfying as in the sun-merged mountains and shelving valleys of his country; and with the immediate charm of whiteness as of rocky water, pale blue of washed skies, and that ineffable lilac, russet, rose, which makes the basis of all southern loveliness. One thinks of him, therefore, as something rather apart, a sort of school in himself, or at most with Domenico, his master, and his follower, della Gatta. But more careful looking will show that his greatest qualities, so balanced and so clear in him, are shared—though often masked by the ungainlinesses of hurried artistic growth—by Pollaiolo, Baldovinetti, Pesellino, let alone Uccello, Castagno, and Masaccio; are, in a word, Tuscan, Florentine. But more than by such studies, the kinship and nationality of Pier della Francesca is proved by reference to the other branches of Tuscan art: his peculiarities correspond to the treatment of line and projection by those early stonemasons of the Baptistery and the Pistoia churches, to the treatment of enclosed spaces and manipulated light in those fifteenth-century sacristies and chapels, to the treatment of mass and boundary in the finest reliefs of Donatello and Donatello's great decorative follower Desiderio. To persons, however, who are ready to think with me that we may be trained to art in fields and on hillsides, the essential Tuscan character of Pier della Francesca is brought home quite as strongly by the particular satisfaction with which we recognise his pictures in some unlikely place, say a Northern gallery. For it is a satisfaction, *sui generis* and with its own emotional flavour, like that which we experience on return to Tuscany, on seeing from the train the white houses on the slopes, the cypresses at the cross roads, the subtler, lower lines of hills, the blue of distant peaks, on realising once more our depth of tranquil love for this austere and gentle country.

XI

Save in the lushness of early summer, Tuscany is, on the whole, pale; a country where the loveliness of colour is that of its luminousness, and where light is paramount. From this arises, perhaps, the austerity of

its true summer—summer when fields are bare, grass burnt to delicate cinnamon and russet, and the hills, with their sere herbs and bushes, seem modelled out of pale rosy or amethyst light; an austerity for the eye corresponding to a sense of healthfulness given by steady, intense heat, purged of all damp, pure like the scents of dry leaves, of warm, cypress resin and of burnt thyme and myrrh of the stony ravines and stubbly fields. On such August days the plain and the more distant mountains will sometimes be obliterated, leaving only the inexpressible suavity of the hills on the same side as the sun, made of the texture of the sky, lying against it like transparent and still luminous shadows. All pictures of such effects of climate are false, even Perugino's and Claude's, because even in these the eye is not sufficiently attracted and absorbed away from the foreground, from the earth to the luminous sky. That effect is the most powerful, sweetest, and most restorative in all nature perhaps; a bath for the soul in pure light and air. That is the incomparable buoyancy and radiance of deepest Tuscan summer. But the winter is, perhaps, even more Tuscan and more austerely beautiful. I am not even speaking of the fact that the mountains, with their near snows and brooding blue storms and ever contending currents of wind and battles and migrations of great clouds, necessarily make much of winter very serious and solemn, as it sweeps down their ravines and across their ridges. I am thinking of the serene winter days of mist and sun, with ranges of hills made of a luminous bluish smoke, and sky only a more luminous and liquid kind, and the olives but a more solid specimen, of the mysterious silvery substance of the world. The marvellous part of it all, and quite impossible to convey, is that such days are not pensive, but effulgent, that the lines of the landscape are not blurred, but exquisitely selected and worked.

XII

A QUALITY LIKE THAT OF Tuscan art is, as I have once before remarked, in some measure, abstract; a general character, like that of a composite photograph, selected and compounded by the repetition of the more general and the exclusion of more individual features. In so far, therefore, it is something rather tended towards in reality than thoroughly accomplished; and its accomplishment, to whatever extent, is naturally due to a tradition, a certain habit among artists and public, which neutralises the refractory tendencies of individuals (the personal

morbidness evident, for instance, in Botticelli) and makes the most of what the majority may have in common—that dominant interest, let us say, in line and mass. Such being the case, this Tuscan quality comes to an end with the local art of the middle ages, and can no longer be found, or only imperfect, after the breaking up and fusion of the various schools, and the arising of eclectic personalities in the earliest sixteenth century. After the painters born between 1450 and 1460, there are no more genuine Tuscans. Leonardo, once independent of Verrocchio and settled in Lombardy, is barely one of them; and Michel Angelo never at all—Michel Angelo with his moods all of Rome or the great mountains, full of trouble, always, and tragedy. These great personalities, and the other eclectics, Raphael foremost, bring qualities to art which it had lacked before, and are required to make its appeal legitimately universal. I should shrink from judging their importance, compared with the older and more local and traditional men. Still further from me is it to prefer this Tuscan art to that, as local and traditional in its way, of Umbria or Venetia, which stands to this as the most poignant lyric or the richest romance stands, let us say, to the characteristic quality, sober yet subtle, of Dante's greatest passages. There is, thank heaven, wholesome art various enough to appeal to many various healthy temperaments; and perhaps for each single temperament more than one kind of art is needful. My object in the foregoing pages has not been to put forward reasons for preferring the art of the Tuscans any more than the climate and landscape of Tuscany; but merely to bring home what the especial charm and power of Tuscan art and Tuscan nature seem to me to be. More can be gained by knowing any art lovingly in itself than by knowing twenty arts from each other through dry comparison.

I have tried to suggest rather than to explain in what way the art of a country may answer to its natural character, by inducing recurrent moods of a given kind. I would not have it thought, however, that such moods need be dominant, or even exist at all, in all the inhabitants of that country. Art, wide as its appeal may be, is no more a product of the great mass of persons than is abstract thought or special invention, however largely these may be put to profit by the generality. The bulk of the inhabitants help to make the art by furnishing the occasional exceptionally endowed creature called an artist, by determining his education and surroundings, in so far as he is a mere citizen; and finally by bringing to bear on him the stored-up habit of acquiescence

in whatever art has been accepted by that public from the artists of the immediate past. In fact, the majority affects the artist mainly as itself has been affected by his predecessors. If, therefore, the scenery and climate call forth moods in a whole people definite enough to influence the art, this will be due, I think, to some especially gifted individual having, at one time or another, brought home those moods to them.

Therefore we need feel no surprise if any individual, peasant or man of business or abstract thinker, reveal a lack, even a total lack, of such impressions as I am speaking of; nor even if among those who love art a great proportion be still incapable of identifying those vague contemplative emotions from which all art is sprung. It is not merely the special endowment of eye, ear, hand, not merely what we call artistic talent, which is exceptional and vested in individuals only. It takes a surplus of sensitiveness and energy to be determined in one's moods by natural surroundings instead of solely by one's own wants or circumstances or business. Now art is born of just this surplus sensitiveness and energy; it is the response not to the impressions made by our private ways and means, but to the impressions made by the ways and means of the visible, sensible universe.

But once produced, art is received, and more or less assimilated, by the rest of mankind, to whom it gives, in greater or less degree, more of such sensitiveness and energy than it could otherwise have had. Art thus calls forth contemplative emotions, otherwise dormant, and creates in the routine and scramble of individual wants and habits a sanctuary where the soul stops elbowing and trampling, and being elbowed and trampled; nay, rather, a holy hill, neither ploughed nor hunted over, a free high place, in which we can see clearly, breathe widely, and, for awhile, live harmlessly, serenely, fully.

XIII

THINKING THESE THOUGHTS FOR THE hundredth time, feeling them in a way as I feel the landscape, I walk home by the dear rock path girdling Fiesole, within sound of the chisels of the quarries. Blackthorn is now mixed in the bare purple hedgerows, and almond blossom, here and there, whitens the sere oak, and the black rocks above. These are the heights from which, as tradition has it, Florence descended, the people of which Dante said—

"Che discese da Fiesole ab antico,
E tiene ancor del monte e del macigno,"

meaning it in anger. But it is true, and truer, in the good sense also. Mountain and rock! the art of Tuscany is sprung from it, from its arduous fruitfulness, with the clear stony stream, and the sparse gentle olive, and the cypress, unshaken by the wind, unscorched by the sun, and shooting inflexibly upwards.

Art and Usefulness

*"Time was when everybody that made anything made a work of art
besides a useful piece of goods, and it gave them pleasure to make it."*

—William Morris,
Address delivered at Burslem, 1881

I

Among the original capitals removed from the outer
colonnade of the ducal palace at Venice there is a series devoted to the
teaching of natural history, and another to that of such general facts
about the races of man, his various moral attributes and activities, as the
Venetians of the fourteenth century considered especially important.
First, botany, illustrated by the fruits most commonly in use, piled up in
baskets which constitute the funnel-shaped capital; each kind separate,
with the name underneath in funny Venetian spelling: *Huva*, grapes;
Fici, figs; *Moloni*, melons; *Zuche*, pumpkins; and *Persici*, peaches. Then,
with Latin names, the various animals: *Ursus*, holding a honeycomb
with bees on it; *Chanis*, mumbling only a large bone, while his cousins,
wolf and fox, have secured a duck and a cock; *Aper*, the wild boar,
munching a head of millet or similar grain.

Now had these beautiful carvings been made with no aim besides
their own beauty, had they represented and taught nothing, they
would have received only a few casual glances, quite insufficient to
make their excellence familiar or even apparent; at best the occasional
discriminative examination of some art student; while the pleased,
spontaneous attentiveness which carries beauty deep into the soul
and the soul's storehouse would have been lacking. But consider these
capitals to have been what they undoubtedly were meant for: the picture
books and manuals off which young folks learned, and older persons
refreshed, their notions of natural history, of geography, ethnology, and
even of morals, and you will realise at once how much attention, and of
how constant and assimilative a kind, they must have received. The child
learns off them that figs (which he never sees save packed in baskets in
the barges at Rialto) have leaves like funny gloves, while *huva*, grapes,
have leaves all ribbed and looking like tattered banners; that the bear is

blunt-featured and eats honeycomb; that foxes and wolves, who live on the mainland, are very like the dogs we keep in Venice, but that they steal poultry instead of being given bones from the kitchen. Also that there are in the world, besides these clean-shaved Venetians in armour or doge's cap, bearded Asiatics and thick-lipped negroes—the sort of people with whom uncle and cousins traffic in the big ships, or among whom grandfather helped the Doge to raise the standard of St. Mark. Also that carpenters work with planes and vices, and stonemasons with mallets and chisels; and that good and wise men are remembered for ever: for here is the story of how Solomon discovered the true mother, and here again the Emperor Trajan going to the wars, and reining in his horse to do justice first to the poor widow. The child looks at the capitals in order to see with his eyes all these interesting things of which he has been told; and, during the holiday walk, drags his parents to the spot, to look again, and to beg to be told once more. And later, he looks at the familiar figures in order to show them to his children; or, perhaps, more wistfully, loitering along the arcade in solitude, to remember the days of his own childhood. And in this manner, the things represented, fruit, animals and persons, and the exact form in which they are rendered: the funnel shape of the capitals, the cling and curl of the leafage, the sharp black undercutting, the clear, lightly incised surfaces, the whole pattern of line and curve, light and shade, the whole pattern of the eye's progress along it, of the rhythm of expansion and restraint, of pressure and thrust, in short, the real work of art, the visible form—become well-known, dwelling in the memory, cohabiting with the various moods, and haunting the fancy; a part of life, familiar, everyday, liked or disliked, discriminated in every particular, become part and parcel of ourselves, for better or for worse, like the tools we handle, the boats we steer, the horses we ride and groom, and the furniture and utensils among which and through whose help we live our lives.

II

Furniture and utensils; things which exist because we require them, which we know because we employ them, these are the type of all great works of art. And from the selfsame craving which insists that these should be shapely as well as handy, pleasant to the eye as well as rational; through the selfsame processes of seeing and

remembering and altering their shapes—according to the same æsthetic laws of line and curve, of surface and projection, of spring and restraint, of clearness and compensation; and for the same organic reasons and by the same organic methods of preference and adaptation as these humblest things of usefulness, do the proudest and seemingly freest works of art come to exist; come to be *just what they are*, and even come *to be at all*.

I should like to state very clearly, before analysing its reasons, what seems to me (and I am proud to follow Ruskin in this as in so many essential questions of art and life) the true formula of this matter. Namely: that while beauty has always been desired and obtained for its own sake, the works in which we have found beauty embodied, and the arts which have achieved beauty's embodying, have always started from impulses or needs, and have always aimed at purposes or problems entirely independent of this embodiment of beauty.

III

THE DESIRE FOR BEAUTY STANDS to art as the desire for righteousness stands to conduct. People do not feel and act from a desire to feel and act righteously, but from a hundred different and differently-combined motives; the desire for righteousness comes in to regulate this feeling and acting, to subject it all to certain preferences and repugnances which have become organic, if not in the human being, at least in human society. Like the desire for righteousness, the desire for beauty is not a spring of action, but a regulative function; it decides the *how* of visible existence; in accordance with deep-seated and barely guessed at necessities of body and soul, of nerves and perceptions, of brain and judgments; it says to all visible objects: since you needs must be, you shall be in *this* manner, and not in that other. The desire for beauty, with its more potent negative, the aversion to ugliness, has, like the sense of right and wrong, the force of a categorical imperative.

Such, to my thinking, is the æsthetic instinct. And I call *Art* whatever kind of process, intellectual and technical, creates, incidentally or purposely, visible or audible forms, and creates them under the regulation of this æsthetic instinct. Art, therefore, is art whenever any object or any action, or any arrangement, besides being such as to serve a practical purpose or express an emotion or transfer a thought, is such

also as to afford the *sui generis* satisfaction which we denote by the adjective: beautiful.

But, asks the reader, if every human activity resulting in visible or audible form is to be considered, at least potentially, as art; what becomes of *art* as distinguished from *craft*, or rather what is the difference between what we all mean by art and what we all mean by *craft*?

To this objection, perfectly justified by the facts of our own day, I would answer quite simply: There is no necessary or essential distinction between what we call *art* and what we call *craft*. It is a pure accident, and in all probability a temporary one, which has momentarily separated the two in the last hundred years. Throughout the previous part of the world's history art and craft have been one and the same, at the utmost distinguishable only from a different point of view: *craft* from the practical side, *art* from the contemplative. Every trade concerned with visible or audible objects or movements has also been an art; and every one of those great creative activities, for which, in their present isolation, we now reserve the name of *art*, has also been a craft; has been connected and replenished with life by the making of things which have a use, or by the doing of deeds which have a meaning.

IV

We must, of course, understand *usefulness* in its widest sense; otherwise we should be looking at the world in a manner too little utilitarian, not too much so. Houses and furniture and utensils, clothes, tools and weapons, must undoubtedly exemplify utility first and foremost because they serve our life in the most direct, indispensable and unvarying fashion, always necessary and necessary to everyone. But once these universal unchanging needs supplied, a great many others become visible: needs to the individual or to individuals and races under definite and changing circumstances. The sonnet or the serenade are useful to the romantic lover in the same manner that carriage-horses and fine clothes are useful to the man who woos more practically-minded ladies. The diamonds of a rich woman serve to mark her status quite as much as to please the unpleasable eye of envy; in the same way that the uniform, the robes and vestments, are needed to set aside the soldier, the magistrate or priest, and give him the right of dealing *ex officio*, not as a mere man among men. And the consciousness of such apparent superfluities, whether they be the expression of wealth or of

hierarchy, of fashion or of caste, gives to their possessor that additional self-importance which is quite as much wanted by the ungainly or diffident moral man as the additional warmth of his more obviously needed raiment is by the poor, chilly, bodily human being. I will not enlarge upon the practical uses which recent ethnology has discovered in the tattooing, the painting, the masks, headdresses, feather skirts, cowries and beads, of all that elaborate ornamentation with which, only a few years back, we were in the habit of reproaching the poor, foolish, naked savages; additional knowledge of their habits having demonstrated rather our folly than theirs, in taking for granted that any race of men would prefer ornament to clothes, unless, as was the case, these ornaments were really more indispensable in their particular mode of life. For an ornament which terrifies an enemy, propitiates a god, paralyses a wild beast, or gains a wife, is a matter of utility, not of æsthetic luxury, so long as it happens to be efficacious, or so long as its efficacy is believed in. Indeed, the gold coach and liveried trumpeters of the nostrum vendor of bygone days, like their less enlivening equivalents in many more modern professions, are of the nature of trade tools, although the things they fashion are only the foolish minds of possible customers.

And this function of expressing and impressing brings us to the other great category of utility. The sculptured pediment or frescoed wall, the hieroglyph, or the map or the book, everything which records a fact or transmits a feeling, everything which carries a message to men or gods, is an object of utility: the coat-of-arms painted on a panel, or the emblem carved upon a church front, as much as the helmet of the knight or the shield of the savage. A church or a religious ceremony, nay, every additional ounce of gilding or grain of incense, or day or hour, bestowed on sanctuary and ritual, are not useful only to the selfish devotee who employs them for obtaining celestial favours; they are more useful and necessary even to the pure-minded worshipper, because they enable him to express the longing and the awe with which his heart is overflowing. For every oblation faithfully brought means so much added moral strength; and love requires gifts to give as much as hunger needs food and vanity needs ornament and wealth. All things which minister to a human need, bodily or spiritual, simple or complex, direct or indirect, innocent or noble, or base or malignant, all such things exist for their use. They do exist, and would always have existed equally if no such quality as beauty had ever arisen to enhance or to excuse their good or bad existence.

V

THE CONCEPTION OF ART AS of something outside, and almost opposed to, practical life, and the tendency to explain its gratuitous existence by a special "play instinct" more gratuitous itself, are due in great measure to our wrong way of thinking and feeling upon no less a matter than human activity as such. The old-fashioned psychology which, ignoring instinct and impulse, explained all action as the result of a kind of calculation of future pleasure and pain, has accustomed us to account for all fruitful human activity, whatever we call *work*, by a wish for some benefit or fear of some disadvantage. And, on the other hand, the economic systems of our time (or, at all events, the systematic exposition of our economic arrangements) have furthermore accustomed us to think of everything like *work* as done under compulsion, fear of worse, or a kind of bribery. It is really taken as a postulate, and almost as an axiom, that no one would make or do anything useful save under the goad of want; of want not in the sense of *wanting to do or make that thing*, but of *wanting to have or be able to do something else*. Hence everything which is manifestly done from no such motive, but from an inner impulse towards the doing, comes to be thought of as opposed to *work*, and to be designated as *play*. Now art is very obviously carried on for its own sake: experience, even of our mercantile age, teaches that if a man does not paint a picture or compose a symphony from an inner necessity as disinterested as that which makes another man look at the picture or listen to the symphony, no amount of self-interest, of disadvantages and advantages, will enable him to do either otherwise than badly. Hence, as I said, we are made to think of art as *play*, or a kind of play.

But play itself, being unaccountable on the basis of external advantage and disadvantage, being, from the false economic point of view, unproductive, that is to say, pure waste, has in its turn to be accounted for by the supposition of surplus energy occasionally requiring to be let off to no purpose, or merely to prevent the machine from bursting. This opposition of work and play is founded in our experience of a social state which is still at sixes and sevens; of a civilisation so imperfectly developed and organised that the majority does nothing save under compulsion, and the minority does nothing to any purpose; and where that little boy's Scylla and Charybdis *all work* and *all play* is effectually realised in a nightmare too terrible and too foolish, above all

too wakingly true, to be looked at in the face without flinching. One wonders, incidentally, how any creature perpetually working from the reasons given by economists, that is to say, working against the grain, from no spontaneous wish or pleasure, can possibly store up, in such exhausting effort, a surplus of energy requiring to be let off! And one wonders, on the other hand, how any really good work of any kind, work not merely kept by dire competitive necessity up to a standard, but able to afford any standard to keep up to, can well be produced save by the letting off of surplus energy; that is to say, how good work can ever be done otherwise than by impulses and instincts acting spontaneously, in fact as play. The reality seems to be that, imperfect as is our poor life, present and past, we are maligning it; founding our theories, for simplicity's sake and to excuse our lack of hope and striving, upon its very worst samples. Wasteful as is the mal-distribution of human activities (mal-distribution worse than that of land or capital!), cruel as is the consequent pressure of want, there yet remains at the bottom of an immense amount of work an inner push different from that outer constraint, an inner need as fruitful as the outer one is wasteful: there remains the satisfaction in work, the wish to work. However outer necessity, "competition," "minimum of cost," "iron law of wages," call it what you choose, direct and misdirect, through need of bread or greed of luxury, the application of human activity, that activity has to be there, and with it its own alleviation and reward: pleasure in work. All decent human work partakes (let us thank the great reasonablenesses of real things!) of the quality of play: if it did not it would be bad or ever on the verge of badness; and if ever human activity attains to fullest fruitfulness, it will be (every experience of our own best work shows it) when the distinction of *work* and of *play* will cease to have a meaning, play remaining only as the preparatory work of the child, as the strength-repairing, balance-adjusting work of the adult.

And meanwhile, through all the centuries of centuries, art, which is the type and sample of all higher, better modes of life, art has given us in itself the concrete sample, the unmistakable type of that needful reconciliation of work and play; and has shown us that there is, or should be, no difference between them. For art has made the things which are useful, and done the things which are needed, in those shapes and ways of beauty which have no aim but our satisfaction.

VI

THE WAY IN WHICH THE work of art is born of a purpose, of something useful to do or desirable to say, and the way in which the suggestions of utility are used up for beauty, can best be shown by a really existing object. Expressed in practical terms the object is humble enough: a little trough with two taps built into a recess in a wall; a place for washing hands and rinsing glasses, as you see the Dominican brothers doing it all day, for I am speaking of the *Lavabo* by Giovanni della Robbia in the Sacristy of Santa Maria Novella in Florence. The whole thing is small, and did not allow of the adjoining room usually devoted to this purpose. The washing and rinsing had to take place in the sacristy itself. But this being the case, it was desirable that the space set apart for these proceedings should at least appear to be separate; the trough, therefore, was sunk in a recess, and the recess divided off from the rest of the wall by pillars and a gable, becoming in this manner, with no loss of real standing room, a building inside a building; the operations, furthermore, implying a certain amount of wetting and slopping, the dryness of the rest of the sacristy, and particularly the *idea* of its dryness (so necessary where precious stuffs and metal vessels are kept) had to be secured not merely by covering a piece of wainscot and floor with tiles, but by building the whole little enclosure (all save the marble trough) of white and coloured majolica, which seemed to say to the oaken and walnut presses, to the great table covered with vestments: "Don't be afraid, you shall not feel a drop from all this washing and rinsing."

So far, therefore, we have got for our lavabo-trough a shallow recess, lined and paved with tiles, and cut off from the frescoed and panelled walls by two pilasters and a rounded gable, of tile work also, the general proportions being given by the necessity of two monks or two acolytes washing the sacred vessels at the same moment. The word *sacred* now leads us to another determining necessity of our work of art. For this place, where the lavabo stands, is actually consecrated; it has an altar; and it is in it that take place all the preparations and preliminaries for the most holy and most magnificent of rites. The sacristy, like the church, is moreover an offering to heaven; and the lavabo, since it has to exist, can exist with fitness only if it also be offered, and made worthy of offering, to heaven. Besides, therefore, those general proportions which have had to be made harmonious for the satisfaction not merely of the builder, but of the people whose eye rests on them daily and hourly;

besides the shapeliness and dignity which we insist upon in all things needful; we further require of this object that it should have a certain superabundance of grace, that it should have colour, elaborate pattern, what we call *ornament*; details which will show that it is a gift, and make it a fit companion for the magnificent embroideries and damasks, the costly and exquisite embossed and enamelled vessels which inhabit that place; and a worthy spectator of the sacred pageantry which issues from this sacristy. The little tiled recess, the trough and the little piece of architecture which frames it all, shall not only be practically useful, they shall also be spiritually useful as the expression of men's reverence and devotion. To whom? Why, to the dear mother of Christ and her gracious angels, whom we place, in effigy, on the gable, white figures on a blue ground. And since this humble thing is also an offering, what can be more appropriate than to hang it round with votive garlands, such as we bind to mark the course of processions, and which we garnish (filling the gaps of glossy bay and spruce pine branches) with the finest fruits of the earth, lemons, and pears, and pomegranates, a grateful tithe to the Powers who make the orchards fruitful. But, since such garlands wither and such fruits decay, and there must be no withering or decaying in the sanctuary, the bay leaves and the pine branches, and the lemons and pears and pomegranates, shall be of imperishable material, majolica coloured like reality, and majolica, moreover, which leads us back, pleasantly, to the humble necessity of the trough, the spurting and slopping of water, which we have secured against by that tiled floor and wainscot.

But here another suggestion arises. Water is necessary and infinitely pleasant in a hot country and a hot place like this domed sacristy. But we have very, oh, so very, little of it in Florence! We cannot even, however great our love and reverence, offer Our Lady and the Angels the thinnest perennial spurt; we must let out the water only for bare use, and turn the tap off instantly after. There is something very disappointing in this; and the knowledge of that dearth of water, of those two taps symbolical of chronic drought, is positively disheartening. Beautiful proportions, delicate patterns, gracious effigies of the Madonna and the angels we can have, and also the most lovely garlands. But we cannot have a fountain. For it is useless calling this a fountain, this poor little trough with two taps. . .

But you *shall* have a fountain! Giovanni della Robbia answers in his heart; or, at least, you shall *feel* as if you had one! And here we may

witness, if we use the eyes of the spirit as well as of the body, one of the strangest miracles of art, when art is married to a purpose. The idea of a fountain, the desirability of water, becomes, unconsciously, dominant in the artist's mind; and under its sway, as under the divining rod, there trickle and well up every kind of thought, of feeling, about water; until the images thereof, visible, audible, tactile, unite and steep and submerge every other notion. Nothing deliberate; and, in all probability, nothing even conscious; those watery thoughts merely lapping dreamily round, like a half-heard murmur of rivers, the waking work with which his mind is busy. Nothing deliberate or conscious, but all the more inevitable and efficacious, this multifold suggestion of water.

And behold the result, the witness of the miracle: In the domed sacristy, the fountain cooling this sultry afternoon of June as it has cooled four hundred Junes and more since set up, arch and pilasters and statued gables hung with garlands by that particular Robbia; cooling and refreshing us with its empty trough and closed taps, without a drop of real water! For it is made of water itself, or the essence, the longing memory of water. It is water, this shining pale amber and agate and grass-green tiling and wainscotting, starred at regular intervals by wide-spread patterns as of floating weeds; water which makes the glossiness of the great leaf-garlands and the juiciness of the smooth lemons and cool pears and pomegranates; water which has washed into ineffable freshness this piece of blue heaven within the gable; and water, you would say, as of some shining fountain in the dusk, which has gathered together into the white glistening bodies and draperies which stand out against that newly-washed æther. All this is evident, and yet insufficient to account for our feelings. The subtlest and most potent half of the spell is hidden; and we guess it only little by little. In this little Grecian tabernacle, every line save the bare verticals and horizontals is a line suggestive of trickling and flowing and bubbles; a line suggested by water and water's movement; and every light and shadow is a light or a shadow suggested by water's brightness or transparent gloom; it is water which winds in tiny meanders of pattern along the shallow shining pillars, and water which beads and dimples along the shady cornice. The fountain has been thought out in longing for water, and every detail of it has been touched by the memory thereof. Water! they wanted water, and they should have it. By a coincidence almost, Giovanni della Robbia has revealed the secret which himself most probably never guessed, in the little landscape of lilac and bluish tiles with which he

filled up the arch behind the taps. Some Tuscan scene, think you? Hills and a few cypresses, such as his contemporaries used for background? Not a bit. A great lake, an estuary, almost a sea, with sailing ships, a flooded country, such as no Florentine had ever seen with mortal eyes; but such as, in his longing for water, he must have dreamed about. Thus the landscape sums up this dream, this realisation of every cool and trickling sight and touch and sound which fills that sacristy as with a spray of watery thoughts. In this manner, with perhaps but a small effort of invention and a small output of fancy, and without departing in the least from the general proportions and shapes and ornaments common in his day, has an artist of the second order left us one of the most exquisitely shapely and poetical of works, merely by following the suggestions of the use, the place, the religious message and that humble human wish for water where there was none.

VII

IT IS DISCOURAGING AND HUMILIATING to think (and therefore we think it very seldom) that nowadays we artists, painters of portraits and landscapes, builders and decorators of houses, pianists, singers, fiddlers, and, quite as really though less obviously, writers, are all of us indirectly helping to keep up the greed which makes the privileged and possessing classes cling to their monopolies and accumulate their possessions. Bitter to realise that, disinterested as we must mostly be (for good artistic work means talent, talent preference, and preference disinterestedness), we are, as Ruskin has already told us, but the parasites of parasites.

For of the pleasure-giving things we make, what portion really gives any pleasure, or comes within reach of giving pleasure, to those whose hands *as a whole class* (as distinguished from the brain of an occasional individual of the other class) produce the wealth we all of us have to live, or try to live, upon? Of course there is the seeming consolation that, like the Reynoldses and Gainsboroughs, the Watteaus and the Fragonards of the past, the Millais and the Sargents (charming sitters, or the reverse, and all), and the Monets and Brabazons, will sooner or later become what we call public property in public galleries. But, meanwhile, the Reynoldses and Gainsboroughs and Watteaus and Fragonards themselves, though the legal property of everybody, are really reserved for those same classes who own their modern

equivalents, simply because those alone have the leisure and culture necessary to enjoy them. The case is not really different for the one or two seemingly more independent and noble artistic individualities, the great decorators like Watts or Besnard; their own work, like their own conscience, is indeed the purer and stronger for their intention of painting not for smoking-rooms and private collections, but for places where all men can see and understand; but then all men cannot see—they are busy or too tired—and they cannot understand, because the language of art has become foreign to them. The same applies to composers and to writers: music and books are cheap enough, but the familiarity with musical forms and literary styles, without which music and books are mere noise and waste-paper, is practically unattainable to the classes who till the ground, extract its stone and minerals, and make, with their hands, every material thing (save works of art) that we possess.

Indeed, one additional reason why, ever since the eighteenth century, art has been set up as the opposite of useful work, and explained as a form of play (though its technical difficulties grew more exorbitant and exhausting year by year) is probably that, in our modern civilisations, art has been obviously produced for the benefit of the classes who virtually do not work, and by artists born or bred to belong to those idle classes themselves. For it is a fact that, as the artist nowadays finds his public only among the comparatively idle (or, at all events, those whose activity distributes wealth in their own favour rather than creates it), so also he requires to be, more and more, in sympathy with their mode of living and thinking: the friend, the client, most often the son, of what we call (with terrible unperceived irony in the words) *leisured* folk. As to the folk who have no leisure (and therefore, according to our modern æsthetics, no *art* because no *play*) they can receive from us privileged persons (when privilege happens to be worth its keep) no benefits save very practical ones. The only kind of work founded on "leisure"—which does in our day not merely increase the advantages of already well-off persons, but actually filter down to help the unleisured producers of our wealth—is not the work of the artist, but of the doctor, the nurse, the inventor, the man of science; who knows? Perhaps almost of the philosopher, the historian, the sociologist: the clearer away of convenient error, the unmaker and remaker of consciences.

As I began by saying, it is not very comfortable, nowadays, to be an

artist, and yet possess a mind and heart. And two of the greatest artists of our times, Ruskin and Tolstoi, have done their utmost to make it more uncomfortable still. So that it is natural for our artists to decide that art exists only for art's own sake, since it cannot nowadays be said to exist for the sake of anything else. And as to us, privileged persons, with leisure and culture fitting us for artistic enjoyment, it is even more natural to consider art as a kind of play: play in which we get refreshed after somebody else's work.

VIII

AND ARE WE REALLY MUCH refreshed? Watching the face and manner, listless, perfunctory or busily attentive, of our fellow-creatures in galleries and exhibitions, and in great measure in concert rooms and theatres, one would imagine that, on the contrary, they were fulfilling a social duty or undergoing a pedagogical routine. The object of the proceeding would rather seem to be negative; one might judge that they had come lest their neighbours should suspect that they were somewhere else, or perhaps lest their neighbours should come instead, according to our fertile methods of society intercourse and of competitive examinations. At any rate, they do not look as if they came to be refreshed, or as if they had taken the right steps towards such spiritual refreshment: the faces and manner of children in a playground, of cricketers on a village green, of Sunday trippers on the beach, or of German townsfolk walking to the beerhouse or café in the deep fragrant woods, present a different appearance. And if we examine into our own feelings, we shall find that even for the most art-loving of us the hours spent in galleries of pictures and statues, or listening to music at concerts, are largely stolen from our real life of real interests and real pleasures; that there enters into them a great proportion of effort and boredom; at the very best that we do not enjoy (nor expect to enjoy) them at all in the same degree as a good dinner in good company, or a walk in bright, bracing weather, let alone, of course, fishing, or hunting, or digging and weeding our little garden.

Of course, if we are really artistic, and if we have the power of analysing our own feelings and motives, we shall know that the gallery or the concert afford occasion for laying in a store of pleasurable impressions, to be enjoyed at the right moment and in the right mood later: outlines of pictures, washes of colour, grouped masses of sculpture,

bars of melody, clang of especial chords or timbre combinations, and even the vague æsthetic emotion, the halo surrounding blurred recollections of sights and sounds. And knowing this, we are content that the act of garnering, of preparing, for such future enjoyment, should lack any steady or deep pleasurableness about itself. But, thinking over the matter, there seems something wrong, derogatory to art and humiliating to ourselves, in this admission that the actual presence of the work of art, sometimes the masterpiece, should give us the minimum, and not the maximum, of our artistic enjoyment. And comparing the usual dead level of such merely potential pleasure with certain rare occasions when we have enjoyed art more at the moment than afterwards, quite vividly, warmly and with the proper reluctant clutch at the divine minute as it passes; making this comparison, we can, I think, guess at the nature of the mischief and the possibility of its remedy.

Examining into our experience, we shall find that, while our lack of enjoyment (our state of æsthetic *aridity*, to borrow the expression of religious mystics) had coincided with a deliberate intention to see or hear works of art, and a consequent clearing away of other claims, and on our attention, in fact, to an effort made more or less in *vacuo*; on the contrary, our Faust-moments ("Stay, thou art beautiful!") of plenitude and consummation, have always come when our activity was already flowing, our attention stimulated, and when, so to speak, the special artistic impressions were caught up into our other interests, and woven by them into our life. We can all recall unexpected delights like Hazlitt's in the odd volume of Rousseau found on the window-seat, and discussed, with his savoury supper, in the roadside inn, after his long day's pleasant tramp.

Indeed, this preparing of the artistic impression by many others, or focussing of others by it, accounts for the keenness of our æsthetic pleasure when on a journey; we are thoroughly alive, and the seen or heard thing of beauty lives *into*, us, or we into it (there is an important psychological law, a little too abstract for this moment of expansiveness, called "the Law of the Summation of Stimuli"). The truth of what I say is confirmed by the frequent fact that the work of art which gives us this full and vivid pleasure (actually refreshing! for here, at last, is refreshment!) is either fragmentary or by no means first-rate. We have remained arid, hard, incapable of absorbing, while whole Joachim quartets flowed and rippled all *round*, but never *into*, us; and then,

some other time, our soul seems to have drunk up (every fibre blissfully steeping) a few bars of a sonata (it was Beethoven's 10th violin, and they were stumbling through it for the first time) heard accidentally while walking up and down under an open window.

It is the same with painting and sculpture. I shall never forget the exquisite poetry and loveliness of that Matteo di Giovanni, "The Giving of the Virgin's Girdle," when I saw it for the first time, in the chapel of that villa, once a monastery, near Siena. Even through the haze of twenty years (like those delicate blue December mists which lay between the sunny hills) I can see that picture, illumined piecemeal by the travelling taper on the sacristan's reed, far more distinctly than I see it today with bodily eyes in the National Gallery. Indeed, it is no exaggeration to say that where it hangs in that gallery it has not once given me one half-second of real pleasure. It is a third-rate picture now; but even the masterpieces, Perugino's big fresco, Titian's "Bacchus and Ariadne," Pier della Francesca's "Baptism"; have they ever given me the complete and steady delight which that mediocre Sienese gave me at the end of the wintry drive, in the faintly illumined chapel? More often than not, as Coleridge puts it, I have "seen, not *felt*, how beautiful they are." But, apart even from fortunate circumstances or enhancing activities, we have all of us experienced how much better we see or hear a work of art with the mere dull help of some historical question to elucidate or technical matter to examine into; we have been able to follow a piece of music by watching for some peculiarity of counterpoint or excellence or fault of execution; and our attention has been carried into a picture or statue by trying to make out whether a piece of drapery was repainted or an arm restored. Indeed, the irrelevant literary programme of concerts and all that art historical lore (information about things of no importance, or none to us) conveyed in dreary monographs and hand-books, all of them perform a necessary function nowadays, that of bringing our idle and alien minds into some sort of relation of business with the works of art which we should otherwise, nine times out of ten, fail really to approach.

And here I would suggest that this necessity of being, in some way, busy about beautiful things in order thoroughly to perceive them, may represent some sterner necessity of life in general; art being, in this as in so many other cases, significantly typical of what is larger than itself. Can we get the full taste of pleasure sought for pleasure's own sake? And is not happiness in life, like beauty in art, rather a means

than an aim: the condition of going on, the replenishing of force; in short, the thing by whose help, not for the sake of which, we feel and act and live?

IX

Beauty is an especial quality in visible or audible shapes and movements which imposes on our soul a certain rhythm and pattern of feeling entirely *sui generis*, but unified, harmonious, and, in a manner, consummate. Beauty is a power in our life, because, however intermittent its action and however momentary, it makes us live, by a kind of sympathy with itself, a life fuller, more vivid, and at the same time more peaceful. But, as the word *sympathy*, *with-feeling*—(*Einfühlen*, "feeling into," the Germans happily put it)—as the word *sympathy* is intended to suggest, this subduing and yet liberating, this enlivening and pacifying power of beautiful form over our feelings is exercised only when our feelings enter, and are absorbed into, the form we perceive; so that (very much as in the case of sympathy with human vicissitudes) we participate in the supposed life of the form while in reality lending *our* life to it. Just as in our relations with our fellow-men, so also in our subtler but even more potent relations with the appearances of things and actions, our heart can be touched, purified, and satisfied only just in proportion as we *give* our heart. And even as it is possible to perceive other human beings and to adjust our action (sometimes heartlessly enough) to such qualities in them as we find practically important to ourselves, without putting out one scrap of sympathy with their own existence as felt by them; so also it is possible to recognise things and actions, to become rapidly aware of such of their peculiarities as most frequently affect us practically, and to consequently adjust our behaviour, without giving our sympathy to their form, without entering into and *living into* those forms; and in so far it is possible for us to remain indifferent to those forms' quality of beauty or ugliness, just as, in the hurry of practical life, we remain indifferent to the stuff our neighbours' souls are made of. This rapid, partial, superficial, perfunctory mode of dealing with what we see and hear constitutes the ordinary, constant, and absolutely indispensable act of recognising objects and actions, of *spotting* their qualities and *twigging* their meaning: an act necessarily tending to more and more abbreviation and rapidity and superficiality, to a sort of shorthand which reduces what has to be understood, and

enables us to pass immediately to understanding something else; according to that law of necessarily saving time and energy.

And so we rush on, recognising, naming, spotting, twigging, answering, using, or parrying; we need not fully *see* the complete appearance of the word we read, of the man we meet, of the street we run along, of the water we drink, the fire we light, the adversary whom we pursue or whom we evade; and in the selfsame manner we need not fully see the form of the building of which we say "This is a Gothic cathedral"—of the picture of which we say "Christ before Pilate"—or of the piece of music of which we say "A cheerful waltz by Strauss" or "A melancholy adagio by Beethoven." Now it is this fragmentary, superficial attention which we most often give to art; and giving thus little, we find that art gives us little, perhaps nothing, in return. For understand: you can be utterly perfunctory towards a work of art without hurrying away from in front of it, or setting about some visible business in its presence. Standing ten minutes before a picture or sitting an hour at a concert, with fixed sight or tense hearing, you may yet be quite hopelessly inattentive if, instead of following the life of the visible or audible forms, and *living yourself* into their pattern and rhythm, you wander off after dramatic or sentimental associations suggested by the picture's subject; or if you let yourself be hypnotised, as pious Wagnerians are apt to be, into monotonous over response (and over and over again response) to the merely emotional stimulation of the sounds. The activity of the artist's soul has been in vain for you, since you do not let your soul follow its tracks through the work of art; he has not created for you, because you have failed to create his work afresh in vivid contemplation.

But attention cannot be forced on to any sort of contemplation, or at least it cannot remain, steady and abiding, by any act of forcing. Attention, to be steady, must be held by the attraction of the thing attended to; and, to be spontaneous and easy, must be carried by some previous interest within the reach of that attractiveness. Above all, attention requires that its ways should have been made smooth by repetition of similar experience; it is excluded, rebutted by the dead wall of utter novelty; for seeing, hearing, understanding is interpreting the unknown by the known, assimilation in the literal sense also of rendering similar the new to the less new. This will explain why it is useless trying to enjoy a totally unfamiliar kind of art: as soon expect to take pleasure in dancing a dance you do not know, and whose rhythm

and step you fail as yet to follow. And it is not only music, as Nietzsche said, but all art, that is but a kind of dancing, a definite rhythmic carrying and moving of the soul. And for this reason there can be no artistic enjoyment without preliminary initiation and training.

Art cannot be enjoyed without initiation and training. I repeat this statement, desiring to impress it on the reader, because, by a coincidence of misunderstanding, it happens to constitute the weightiest accusation in the whole of Tolstoi's very terrible (and, in part, terribly justified) recent arraignment of art. For of what use is the restorative and refreshing power, this quality called beauty, if the quality itself cannot be recognised save after previous training? And what moral dignity, nay, what decent innocence, can there be in a kind of relaxation from which lack of initiation excludes the vast majority of men, the majority which really labours, and therefore has a real claim to relaxation and refreshment?

This question of Tolstoi's arises from that same limiting of examination to a brief, partial, and, as it happens, most transitional and chaotic present, which has given us that cut-and-dried distinction between work and play; and, indeed, the two misconceptions are very closely connected. For even as our present economic system of production for exchange rather than for consumption has made us conceive *work* as *work* done under compulsion for someone else, and *play* as *play*, with no result even to ourselves; so also has the economic system which employs the human hand and eye merely as a portion of a complicated, monotonously working piece of machinery, so also has our present order of mechanical and individual production divided the world into a small minority which sees and feels what it is about, and a colossal majority which has no perception, no conception, and, consequently, no preferences attached to the objects it is employed (by the methods of division of labour) to produce, so to speak, without seeing them. Tolstoi has realised that this is the present condition of human labour, and his view of it has been corrected neither by historical knowledge nor by psychological observation. He has shown us *art*, as it nowadays exists, divided and specialised into two or three "fine arts," each of which employs exceptional and highly trained talent in the production of objects so elaborate and costly, so lacking in all utility, that they can be possessed only by the rich few; objects, moreover, so unfamiliar in form and in symbol that only the idle can learn to enjoy (or pretend to enjoy) them after a special preliminary initiation and training.

X

INITIATION AND TRAINING, WE HAVE returned to those wretched words, for we also had recognised that without initiation and training there could be no real enjoyment of art. But, looking not at this brief, transitional, and topsy-turvey present, but at the centuries and centuries which have evolved, not only art, but the desire and habit thereof, we have seen what Tolstoi refused to see, namely, that wherever and whenever (that is to say, everywhere and at all times save these present European days) art has existed spontaneously, it has brought with it that initiation and training. The initiation and training, the habit of understanding given qualities of form, the discrimination and preference thereof, have come, I maintain, as a result of practical utility.

Or rather: out of practical utility has arisen the art itself, and the need for it. The attention, the familiarity which made beauty enjoyable had previously made beauty necessary. It was because the earthenware lamp, the bronze pitcher, the little rude household idols displayed the same arrangements of lines and surfaces, presented the same patterns and features, embodied, in a word, the same visible rhythms of being, that the Greeks could understand without being taught the temples and statues of Athens, Delphi or Olympia. It was because the special form qualities of ogival art (so subtle in movement, unstable in balance and poignant in emotion that a whole century of critical study has scarce sufficed to render them familiar to us) were present in every village tower, every window coping, every chair-back, in every pattern carved, painted, stencilled or woven during the Gothic period; it was because of this that every artisan of the Middle Ages could appreciate less consciously than we, but far more deeply, the loveliness and the wonder of the great cathedrals. Nay, even in our own times we can see how, through the help of all the cheapest and most perishable household wares, the poorest Japanese is able to enjoy that special peculiarity and synthesis of line and colour and perspective which strikes even initiated Westerns as so exotic, far-fetched and almost wilfully unintelligible.

I have said that thanks to the objects and sights of everyday use and life the qualities of art could be perceived and enjoyed. It may be that it was thanks to them that art had any qualities and ever existed at all. For, however much the temple, cathedral, statue, fresco, the elaborate bronze or lacquer or coloured print, may have reacted on the form, the proportions and linear rhythms and surface arrangements, of all common

useful objects; it was in the making of these common useful objects (first making by man of genius and thousandfold minute adaptation by respectful mediocrity) that the form qualities came to exist. One may at least hazard this supposition in the face of the extreme unlikeliness that the complexity and perfection of the great works of art could have been obtained solely in works so necessarily rare and few; and that the particular forms constituting each separate style could have originated save under the repeated suggestion of everyday use and technique. And can we not point to the patterns grown out of the necessities of weaving or basket-making, the shapes started by the processes of metal soldering or clay squeezing; let alone the innumerable categories of form manifestly derived from the mere convenience of handling or using, of standing, pouring, holding, hanging up or folding? This much is certain, that only the manifold application of given artistic forms in useful common objects is able to account for that very slow, gradual and unconscious alteration of them which constitutes the spontaneous evolution of artistic form; and only such manifold application could have given that almost automatic certainty of taste which allowed the great art of the past to continue perpetually changing, through centuries and centuries, and adapting itself over immense geographical areas to every variation of climate, topography, mode of life, or religion. Unless the forms of ancient art had been safely embodied in a hundred modest crafts, how could they have undergone the imperceptible and secure metamorphosis from Egyptian to Hellenic, from Greek to Græco-Roman, and thence, from Byzantine, have passed, as one great half, into Italian mediæval art? or how, without such infinite and infinitely varied practice of minute adaptation to humble needs, could Gothic have given us works so different as the French cathedrals, the Ducal Palace, the tiny chapel at Pisa, and remained equally great and wonderful, equally *Gothic*, in the ornament of a buckle as in the porch of Amiens or of Reims?

Beauty is born of attention, as happiness is born of life, because attention is rendered difficult and painful by lack of harmony, even as life is clogged, diminished or destroyed by pain. And therefore, when there ceases to exist a close familiarity with visible objects or actions; when the appearance of things is passed over in perfunctory and partial use (as we see it in all mechanical and divided labour); when the attention of all men is not continually directed to shape through purpose, then there will cease to be spontaneous beauty and the spontaneous appreciation

of beauty, because there will be no need for either. Beauty of music does not exist for the stone-deaf, nor beauty of painting for the purblind; but beauty of no kind whatever, nor in any art, can really exist for the inattentive, for the over-worked or the idle.

XI

THAT MUSIC SHOULD BE SO far the most really alive of all our modern arts is a fact which confirms all I have argued in the foregoing pages. For music is of all arts the one which insists on most co-operation on the part of its votaries. Requiring to be performed (ninety-nine times out of a hundred) in order to be enjoyed, it has made merely *musical people* into performers, however humble; and has by this means called forth a degree of attention, of familiarity, of practical effort, which makes the art enter in some measure into life, and in that measure, become living. To play an instrument, however humbly, to read at sight, or to sing, if only in a choir, is something wholly different from lounging in a gallery or wandering on a round of cathedrals: it means acquired knowledge, effort, comparison, self-restraint, and all the realities of manipulation; quite apart even from trying to read the composer's intentions, there is in learning to strike the keys with a particular part of the finger-tips, or in dealing out the breath and watching intonation and timbre in one's own voice, an output of care and skill akin to those of the smith, the potter or the glass blower: all this has a purpose and is work, and brings with it disinterested work's reward, love.

To find the analogy of this co-operation in the arts addressing themselves to the eye, we require, nowadays, to leave the great number who merely enjoy (or ought to enjoy) painting, sculpture or architecture, and seek, now that craft is entirely divorced from art, among the small minority which creates, or tries to create. Artistic enjoyment exists nowadays mainly among the class of executive artists; and perhaps it is for this very reason, and because all chance of seeing or making shapely things has ceased in other pursuits, that the "fine arts" are so lamentably overstocked; the man or woman who would have been satisfied with playing the piano enough to read a score or sing sufficiently to take part in a chorus, has, in the case of other arts, to undergo the training of a painter, sculptor or art critic, and often to delude himself or herself with grotesque ambitions in one of these walks.

XII

BE THIS AS IT MAY, and making the above happy and honourable exception in favour of music, it is no exaggeration to say that in our time it is only artists who get real pleasure out of art, because it is only artists who approach art from the side of work and bring to it work's familiar attention and habitual energy. Indeed, paradoxical as it may sound, art has remained alive during the nineteenth century, and will remain alive during the twentieth, only and solely because there has been a large public of artists.

Of artists, I would add, of quite incomparable vigour and elasticity of genius, and of magnificent disinterestedness and purity of heart. For let us remember that they have worked without having the sympathy of their fellow-men, and worked without the aid and comfort of allied crafts: that they have created while cut off from tradition, unhelped by the manifold suggestiveness of useful purpose or necessary message; separated entirely from the practical and emotional life of the world at large; tiny little knots of voluntary outlaws from a civilisation which could not understand them; and, whatever worldly honours may have come to mock their later years, they have been weakened and embittered by early solitude of spirit. No artistic genius of the past has been put through such cruel tests, has been kept on such miserably short commons, as have our artists of the last hundred years, from Turner to Rossetti and Watts, from Manet and Degas and Whistler to Rodin and Albert Besnard. And if their work has shown lapses and failings; if it has been, alas, lacking at times in health or joy or dignity or harmony, let us ask ourselves what the greatest individualities of Antiquity and the Middle Ages would have produced if cut off from the tradition of the Past and the suggestion of the Present—if reduced to exercise art outside the atmosphere of life; and let us look with wonder and gratitude on the men who have been able to achieve great art even for only art's own sake.

XIII

NO BETTER ILLUSTRATION OF THIS could be found than the sections of the Paris Exhibition which came under the heading of *Decorative Art*.

Decoration. But decoration of what? In reality of nothing. All the objects—from the jewellery and enamels to the furniture and

hangings—which this decorative art is supposed to decorate, are the merest excuse and sham. Not one of them is the least useful, or at all events useful once it is decorated. And nobody wants it to be useful. What *is* wanted is a pretext, for *doing art* on the side of the artist, for buying costly things on the side of the public. And behind this pretext there is absolutely no genuine demand for any definite object serving any definite use; none of that insistence (which we see in the past) that the shape, material, and colour should be the very best for practical purposes; and of that other insistence, marvellously blended with the requirements of utility, that the shape, material and colour should also be as beautiful as possible. The invaluable suggestions of real practical purpose, the organic dignity of integrated habit and necessity, the safety of tradition, the spiritual weightiness of genuine message, all these elements of creative power are lacking. And in default of them we see a great amount of artistic talent, artificially fed and excited by the teaching and the example of every possible past or present art, exhausting itself in attempts to invent, to express, to be something, anything, so long as it is new. Hence forms gratuitous, without organic quality or logical cogency, pulled about, altered and re-altered, carried to senseless finish and then wilfully blurred. Hence that sickly imitation, in a brand-new piece of work, of the effects of time, weather, and of every manner of accident or deterioration: the pottery and enamels reproducing the mere patina of age or the trickles of bad firing; the relief work in marble or metal which looks as if it had been rolled for centuries in the sea, or corroded by acids under ground. And the total effect, increased by all these methods of wilful blunting and blurring, is an art without stamina, tired, impotent, short-lived, while produced by an excessive expense of talent and effort of invention.

For here we have the mischief: all the artistic force is spent by the art in merely keeping alive; and there is no reserve energy for living with serenity and depth of feeling. The artist wears himself out, to a great extent, in wondering what he shall do (there being no practical reason for doing one thing more than another, or indeed anything at all), instead of applying his power, with steady, habitual certainty of purpose and efficiency of execution, to doing it in the very best way. Hence, despite this outlay of inventive force, or rather in direct consequence thereof, there is none of that completeness and measure and congruity, that restrained exuberance of fancy, that more than adequate carrying out, that all-round harmony, which are possible only when the artist

is altering to his individual taste some shape already furnished by tradition or subduing to his pleasure some problem insisted on by practical necessity.

Meanwhile, all round these galleries crammed with useless objects barely pretending to any utility, round these pavilions of the Decorative Arts, the Exhibition exhibits (most instructive of all its shows) samples of the most marvellous indifference not merely to beauty, peace and dignity, but to the most rudimentary æsthetic and moral comfort. For all the really useful things which men take seriously because they increase wealth and power, because they save time and overcome distance; all these "useful" things have the naïve and colossal ugliness of rudimentary animals, or of abortions, of everything hurried untimely into existence: machines, sheds, bridges, trams, motor-cars: not one line corrected, not one angle smoothed, for the sake of the eye, of the nerves of the spectator. And all of it, both decorative futility and cynically hideous practicality (let alone the various exotic raree shows from distant countries or more distant centuries) expect to be enjoyed after a jostle at the doors and a scurry along the crowded corridors, and to the accompaniment of every rattling and shrieking and jarring sound. For mankind in our days intends to revel in the most complicated and far-fetched kinds of beauty while cultivating convenient callousness to the most elementary and atrocious sorts of ugliness. The art itself reveals it; for even in its superfine isolation and existence for its own sake only, art cannot escape its secondary mission of expressing and recording the spirit of its times. These elaborate æsthetic baubles of the "Decorative Arts" are full of quite incredibly gross barbarism. And, even as the iron chest, studded with nails, or the walnut press, unadorned save by the intrinsic beauty and dignity of their proportions, and the tender irregularities of their hammered surface, the subtle bevelling of their panels; even as these humble objects in some dark corner of an Italian castle or on the mud floor of a Breton cottage, symbolise in my mind the most intense artistic sensitiveness and reverence of the Past; so, here at this Exhibition, my impressions of contemporary over-refinement and callousness are symbolised in a certain cupboard, visibly incapable of holding either linen or garments or crockery or books, of costly and delicately polished wood, but shaped like a packing-case, and displaying with marvellous impartiality two exquisitely cast and chased doorguard plates of far-fetched, many-tinted alloys of silver, and—a set of hinges, a lock and a key, such as the village ironmonger supplies in blue paper

parcels of a dozen. A mere coincidence, an accident, you may object; an unlucky oversight which cannot be fairly alleged against the art of our times. Pardon me: there may be coincidences and accidents in other matters, but there are none in art; because the essence of art is to sacrifice even the finest irrelevancies, to subordinate the most refractory details, to subdue coincidence and accident into seeming purpose and harmony. And whatever our practical activity, in its identification of time and money, may allow itself in the way of "scamping" and of "shoddy"—art can never plead an oversight, because art, in so far as it *is* art, represents those organic and organised preferences in the domain of form, those imperative and stringent demands for harmony, which see everything, feel everything, and know no law or motive save their own complete satisfaction.

Art for art's sake! We see it nowhere revealed so clearly as in the Exhibition, where it masks as "Decorative Art." Art answering no claim of practical life and obeying no law of contemplative preference, art without root, without organism, without logical reason or moral decorum, art for mere buying and selling, art which expresses only self-assertion on the part of the seller, and self-satisfaction on the part of the buyer. A walk through this Exhibition is an object-lesson in a great many things besides æsthetics; it forces one to ask a good many of Tolstoi's angriest questions; but it enables one also, if duly familiar with the art of past times, to answer them in a manner different from Tolstoi's.

One carries away the fact, which implies so many others, that not one of these objects is otherwise than expensive; expensive, necessarily and intentionally, from the rarity both of the kind of skill and of the kind of material; these things are reserved by their price as well as their uselessness, for a small number of idle persons. They have no connection with life, either by penetrating, by serviceableness, deep into that of the individual; or by spreading, by cheapness, over a wide surface of the life of the nations.

XIV

THE MOMENT HAS NOW COME for that inevitable question, with which friendly readers unintentionally embarrass, and hostile ones purposely interrupt, any exposition of mal-adjustment in the order of the universe: But what remedy do you propose?

Mal-adjustments of a certain gravity are not set right by proposable arrangements: they are remedied by the fulness and extent of the feeling against them, which employs for its purposes and compels into its service all the unexpected and incalculable coincidences and accidents which would otherwise be wasted, counteracted or even used by some different kind of feeling. And the use that a writer can be—even a Ruskin or a Tolstoi—is limited not to devising programmes of change (mere symptoms often that some unprogrammed change is preparing), but to nursing the strength of that great motor which creates its own ways and instruments: impatience with evil conditions, desire for better.

A cessation of the special æsthetic mal-adjustment of our times, by which art is divorced from life and life from art, is as difficult to foretell in detail as the new-adjustment between labour and the other elements of production which will, most probably, have to precede it.

A healthy artistic life has indeed existed in the past through centuries of social wrongness as great as our own, and even greater; indeed, such artistic life, more or less continuous until our day, attests the existence of great mitigations in the world's former wretchedness (such as individuality in labour, spirit of co-operative solidarity, religious feeling: but perhaps the most important alleviations lie far deeper and more hidden)—mitigations without which there would not have been happiness and strength enough to produce art; nor, for the matter of that, to produce what was then the future, including ourselves and our advantages and disadvantages. The existence of art has by no means implied, as Ruskin imagined, with his teleological optimism and tendency to believe in Eden and banishment from Eden, that people once lived in a kind of millennium; it merely shows that, however far from millennial their condition, there was stability enough to produce certain alleviations, and notably the alleviations without which art cannot exist, and the alleviations which art itself affords.

It is not therefore the badness of our present social arrangements (in many ways far less bad than those of the past) which is responsible for our lack of all really vital, deep-seated, widely spread and happiness-giving art; but merely the feature in this latter-day badness which, after all, is our chief reason for hope: the fact that the social mal-adjustments of this century are, to an extent hitherto unparalleled, the mal-adjustments incident to a state of over-rapid and therefore insufficiently deep-reaching change, of superficial legal and material improvements

extending in reality only to a very small number of persons and things, and unaccompanied by any real renovation in the thought, feeling or mode of living of the majority; the mal-adjustment of transition, of disorder, and perfunctoriness, by the side of which the regularly recurring disorders of the past—civil wars, barbarian invasions, plagues, etc., are incidents leaving the foundation of life unchanged, transitional disorders, which we fail to remark only because we are ourselves a part of the hurry, the scuffle, and the general wastefulness. How soon and how this transition period of ours will come to an end, it is difficult, perhaps impossible, to foretell; but that it *must* soon end is certain, if only for one reason: namely, that the changes accumulated during our times must inevitably work their way below the surface; the new material and intellectual methods must become absorbed and organised, and thereby produce some kind of interdependent and less easily disturbed new conditions; briefly, that the amount of alteration we have witnessed will occasion a corresponding integration. And with this period of integration and increasing organisation and comparative stability there will come new alleviations and adjustments in life, and with these, the reappearance in life of art.

XV

IN WHAT MANNER IT IS absurd, merely foolishly impatient or foolishly cavilling, to ask. Not certainly by a return to the past and its methods, but by the coming of the future with new methods having the same result: the maintenance and tolerable quality of human life, of body and soul. Hence probably by a further development of democratic institutions and machine industry, but democratic institutions neither authoritative nor *laissez faire*; machinery of which the hand and mind of men will be the guide, not the slave.

One or two guesses may perhaps be warranted. First, that the distribution of wealth, or more properly of work and idleness, will gradually be improved, and the exploitation of individuals in great gangs cease; hence that the workman will be able once more to see and shape what he is making, and that, on the other side, the possessor of objects will have to use them, and therefore learn their appearance and care for them; also that many men will possess enough, and scarcely any men possess much more than enough, so that what there is of houses, furniture, chattels, books or pictures in private possession may

be enjoyed at leisure and with unglutted appetite, and for that reason be beautiful. We may also guess that willing co-operation in peaceful employments, that spontaneous formation of groups of opinion as well as of work, and the multiplication of small centres of activity, may create a demand for places of public education and amusement and of discussion and self-expression, and revive those celebrations, religious and civil, in which the art of Antiquity and of the Middle Ages found its culmination; the service of large bodies and of the community absorbing the higher artistic gifts in works necessarily accessible to the multitude; and the humbler talents—all the good amateur quality at present wasted in ambitious efforts—being applied in every direction to the satisfaction of individual artistic desire.

If such a distribution of artistic activity should seem, to my contemporaries, Utopian, I would point out that it has existed throughout the past, and in states of society infinitely worse than are ever likely to recur. For even slaves and serfs could make unto themselves some kind of art befitting their conditions; and even the most despotic aristocracies and priesthoods could adequately express their power and pride only in works which even the slave and serf was able to see. In the whole of the world's art history, it is this present of ours which forms the exception; and as the changes of the future will certainly be for greater social health and better social organisation, it is not likely that this bad exception will be the beginning of a new rule.

XVI

MEANWHILE WE CAN, IN SOME slight measure, foretell one or two of the directions in which our future artistic readjustment is most likely to begin, even apart from that presumable social reorganisation and industrial progress which will give greater leisure and comfort to the workers, and make their individual character the guide, and not the slave, of this machinery. Such a direction is already indicated by one of our few original and popular forms of art: the picture-book and the poster, which, by the new processes of our colour printing, have placed some of the most fanciful and delicate of our artists—men like Caldecott and Walter Crane, like Cheret and Boutet de Monvel, at the service of everyone equally. Moreover, it is probable that long before machinery is so perfected as to demand individual guidance, preference and therefore desire for beauty, and long before a corresponding

readjustment of work and leisure, the eye will have again become attentive through the necessities of rational education. The habit of teaching both adults and children by demonstration rather than precept, by awaking the imagination rather than burdening the memory, will quite undoubtedly recall attention to visible things, and thereby open new fields to art: geography, geology, natural history, let alone history in its vaster modern sociological and anthropological aspect, will insist upon being taught no longer merely through books, but through collections of visible objects; and, for all purposes of reconstructive and synthetic conception, through pictures.

And, what is more, the sciences will afford a new field for poetic contemplation; while the philosophy born of such sciences will synthetise new modes of seeing life and demand new visible symbols. The future will create cosmogonies and Divine Comedies more numerous, more various, than those on sculptured Egyptian temples and Gothic cathedrals, and Bibles more imaginative perhaps than the ones painted in the Pisa Campo Santo and in the Sixtine Chapel. The future? Nay, we can see a sample already in the present. I am alluding to the panels by Albert Besnard in the School of Pharmacy in Paris, a series illustrating the making of medicinal drugs, their employment and the method and subject-matter of the sciences on which pharmaceutical practice is based. Not merely the plucking and drying of the herbs in sunny, quiet botanical gardens, and the sorting and mingling of earths and metals among the furnaces of the laboratory; not merely the first tremendous tragic fight between the sudden sickness and the physician, and the first pathetic, hard-won victory, the first weary but rapturous return out of doors of the convalescent; but the life of the men on whose science our power for life against death is based: the botanists knee-deep in the pale spring woods; the geologists in the snowy hollows of the great blue mountain; the men themselves, the youths listening and the elder men teaching, grave and eager intellectual faces, in the lecture rooms. And, finally, the things which fill the minds of these men, their thoughts and dreams, the poetry they have given to the world; the poetry of that infinitely remote, dim past, evoked out of cavern remains and fossils—the lake dwellers among the mists of melting glaciers; the primæval horses playing on the still manless shores; the great saurians plunging in the waves of long-dried seas; the jungles which are now our coal beds; and see! the beginning of organic life, the first callow vegetation on the stagnant waters in

the dawn-light of the world. The place is but a mean boarded and glazed vestibule; full of the sickly fumes of chemicals; and the people who haunt it are only future apothecaries. But the compositions are as spacious and solemn, the colours as tender and brilliant, and the poetry as high and contemplative as that of any mediæval fresco; it is all new also, undreamed of, *sui generis*, in its impersonal cosmic suggestiveness, as in its colouring of opal, and metallic patinas, and tea rose and Alpine ice cave.

XVII

I HAVE ALLUDED ALREADY TO the fact that, perhaps because of the part of actual participating work which it entails, music is the art which has most share in life and of life, nowadays. It seems probable therefore that its especial mission may be to keep alive in us the feeling and habit of art, and to transmit them back to those arts of visible form to which it owes, perhaps, the training necessary to its own architectural structure and its own colour combinations. Compared with the arts of line and projection, music seems at a certain moral disadvantage, as not being applicable to the things of everyday use, and also not educating us to the better knowledge of the beautiful and significant things of nature. In connection with this kind of blindness, music is also compatible (as we see by its flourishing in great manufacturing towns) with a great deal of desecration of nature and much hand-to-mouth ruthlessness of life. But, on the other hand, music has the especial power of suggesting and regulating emotion, and the still more marvellous faculty of creating an inner world for itself, inviolable because ubiquitous.

And, therefore, with its audible rhythms and harmonies, its restrained climaxes and finely ordered hierarchies, music may discipline our feelings, or rather what underlies our feelings, the almost unconscious life of our nerves, to modalities of order and selection, and make the spaceless innermost of our spirit into some kind of sanctuary, swept and garnished, until the coming of better days.

XVIII

ACCORDING TO A CERTAIN CLASS of thinkers, among whom I find Guyau and other men of note, art is destined partially to replace religion in our lives. But with what are you going to replace religion itself in

art? For the religious feeling, whenever it existed, gave art an element of thoroughness which the desire for pleasure and interest, even for æsthetic pleasure and interest, does not supply. An immense fulness of energy is due to the fact that beautiful things, as employed by religion, were intended to be beautiful all through, adequate in the all-seeing eye of God or Gods, not merely beautiful on the surface, on the side turned towards the glance of man. For, in religious art, beautiful things are an oblation; they are the best that we can give, as distinguished from a pleasure arranged for ourselves and got as cheap as possible. Herein lies the impassable gulf between the church and theatre, considered æsthetically; for it is only in the basest times, of formalism in art as in religion, of superstition and sensualism, that we find the church imitating the theatre in its paper glories and plaster painted like marble. The real, living religious spirit insists on bringing, as in St. Mark's, a gift of precious material, of delicate antique ornament, with every shipload. The crown of the Madonna is not, like the tragedy queen's, of tinsel, the sacrament is not given in an empty chalice. The priest, even where he makes no effort to be holy as a man, is at least sacred as a priest; whereas there is something uncomfortable in the sense that the actor is only pretending to be this or the other, and we ourselves pretending to believe him; there is a thin and acid taste in the shams of the stage and in all art which, like that of the stage, exists only to the extent necessary to please our fancy or excite our feelings. Why so? For is not pleasing the fancy and exciting the feelings the real, final use of art? Doubtless. But there would seem to be in nature a law not merely of the greater economy of means, but also of the greatest output of efficacy: effort helping effort, and function, function; and many activities, in harmonious interaction, obtaining a measure of result far surpassing their mere addition. The creations of our mind are, of course, mere spiritual existences, things of seeming, akin to illusions; and yet our mind can never rest satisfied with an unreality, because our mind is active, penetrative and grasping, and therefore craves for realisation, for completeness and truth, and feels bruised and maimed whenever it hits against a dead wall or is pulled up by a contradiction; nay, worst of all, it grows giddy and faint when suddenly brought face to face with emptiness. All insufficiency and shallowness means loss of power; and it is such loss of power that we remark when we compare with the religious art of past times the art which, every day more and more, is given us by the hurried and over-thrifty (may I say "Reach-me-down"?)

hands of secularism. The great art of Greece and of the Middle Ages most often represents something which, to our mind and feelings, is as important, and even as beautiful, as the representation itself; and the representation, the actual "work of art" itself, gains by that added depth and reverence of our mood, is carried deeper (while helping to carry deeper) into our soul. Instead of which we moderns try to be satisfied with allowing the seeing part of us to light on something pleasant and interesting, while giving the mind only triviality to rest upon; and the mind goes to sleep or chafes to move away. We cannot live intellectually and morally in presence of the idea, say, of a jockey of Degas or one of his ballet girls in contemplation of her shoe, as long as we can live æsthetically in the arrangement of lines and masses and dabs of colour and interlacings of light and shade which translate themselves into this *idea* of jockey or ballet girl; we are therefore bored, ruffled, or, what is worse, we learn to live on insufficient spiritual rations, and grow anæmic. Our shortsighted practicality, which values means while disregarding ends, and conceives usefulness only as a stage in making some other *utility*, has led us to suppose that the desire for beauty is compatible, nay commensurate, with indifference to reality: the *real* having come to mean that which you can plant, cook, eat or sell, not what you can feel and think.

This notion credits us with an actual craving for something which should exist as little as possible, in one dimension only, so to speak, or as upon a screen (for fear of occupying valuable space which might be given to producing more food than we can eat); whereas what we desire is just such beauty as will surround us on all sides, such harmony as we can live in; our soul, dissatisfied with the reality which happens to surround it, seeks on the contrary to substitute a new reality of its own making, to rebuild the universe, like Omar Khayyam, according to the heart's desire. And nothing can be more different than such an instinct from the alleged satisfaction in playing with dolls and knowing that they are not real people. By an odd paradoxical coincidence, that very disbelief in the *real* character of art, and that divorce betwixt art and utility, is really due to our ultra-practical habit of taking seriously only the serviceable or instructive sides of things: the quality of beauty, which the healthy mind insists upon in everything it deals with, getting to be considered as an idle adjunct, fulfilling no kind of purpose; and therefore, as something detachable, separate, and speedily relegated to the museum or lumber-room where we keep our various shams: ideals,

philosophies, all the playthings with which we sometimes wile away our idleness. Whereas in fact a great work of art, like a great thought of goodness, exists essentially for our more thorough, our more *real* satisfaction: the soul goes into it with all its higher hankerings, and rests peaceful, satisfied, so long as it is enclosed in this dwelling of its own choice. And it is, on the contrary, the flux of what we call real life, that is to say, of life imposed on us by outer necessities and combinations, which is so often one-sided, perfunctory, not to be dwelt upon by thought nor penetrated into by feeling, and endurable only according to the angle or the lighting up—the angle or lighting up called "purpose" which we apply to it.

XIX

WITH WHAT, I VENTURED TO ask just now, are you going to fill the place of religion in art?

With nothing, I believe, unless with religion itself. Religion, perhaps externally unlike any of which we have historical experience; but religion, whether individual or collective, possessing, just because it is immortal, all the immortal essence of all past and present creeds. And just because religion is the highest form of human activity, and its utility is the crowning one of thoughtful and feeling life, just for this reason will religion return, sooner or later, to be art's most universal and most noble employer.

XX

IN THE FOREGOING PAGES I have tried to derive the need of beauty from the fact of attention, attention to what we do, think and feel, as well as see and hear; and to demonstrate therefore that all spontaneous and efficient art is *the making and doing of useful things in such manner as shall be beautiful*. During this demonstration I have, incidentally, though inexplicitly, pointed out the utility of art itself and of beauty. For beauty is that mode of existence of visible or audible or thinkable things which imposes on our contemplating energies rhythms and patterns of unity, harmony and completeness; and thereby gives us the foretaste and the habit of higher and more perfect forms of life. Art is born of the utilities of life; and art is in itself one of life's greatest utilities.

Wasteful Pleasures

"Er muss lernen edler begehren, damit er nicht nötig habe, erhaben zu wollen."

—Schiller, *"Ästhetische Erziehung."*

I

A pretty, Caldecott-like moment, or rather minute, when the huntsmen stood on the green lawn round the moving, tail-switching, dapple mass of hounds; and the red coats trotted one by one from behind the screens of bare trees, delicate lilac against the slowly moving grey sky. A delightful moment, followed, as the hunt swished past, by the sudden sense that these men and women, thus whirled off into what may well be the sole poetry of their lives, are but noisy intruders into these fields and spinnies, whose solemn, secret speech they drown with clatter and yelp, whose mystery and charm stand aside on their passage, like an interrupted, a profaned rite.

Gone; the yapping and barking, the bugle-tootling fade away in the distance; and the trees and wind converse once more.

This West Wind, which has been whipping up the wan northern sea, and rushing round the house all this last fortnight, singing its big ballads in corridor and chimney, piping its dirges and lullabies in one's back-blown hair on the sand dunes—this West Wind, with its many chaunts, its occasional harmonies and sudden modulations mocking familiar tunes, can tell of many things: of the different way in which the great trunks meet its shocks and answer vibrating through innermost fibres; the smooth, muscular boles of the beeches, shaking their auburn boughs; the stiff, rough hornbeams and thorns isolated among the pastures; the ashes whose leaves strew the roads with green rushes; the creaking, shivering firs and larches. The West Wind tells us of the way how the branches spring outwards, or balance themselves, or hang like garlands in the air, and carry their leaves, or needles, or nuts; and of their ways of bending and straightening, of swaying and trembling. It tells us also, this West Wind, how the sea is lashed and furrowed; how the little waves spring up in the offing, and the big waves

rise and run forward and topple into foam; how the rocks are shaken, the sands are made to hiss and the shingle is rattled up and down; how the great breakers vault over the pier walls, leap thundering against the breakwaters, and disperse like smoke off the cannon's mouth, like the whiteness of some vast explosion.

These are the things which the Wind and the Woods can talk about with us, nay, even the gorse and the shaking bents. But the hunting folk pass too quickly, and make too much noise, to hear anything save themselves and their horses' hoofs and their bugle and hounds.

II

I HAVE TAKEN FOX-HUNTING AS the type of a pleasure *which destroys something*, just because it is, in many ways, the most noble and, if I may say so, the most innocent of such pleasures. The death, the, perhaps agonising, flight of the fox, occupy no part of the hunter's consciousness, and form no part of his pleasure; indeed, they could, but for the hounds, be dispensed with altogether. There is a fine community of emotion between men and creatures, horses and dogs adding their excitement to ours; there is also a fine lack of the mere feeling of trying to outrace a competitor, something of the collective and almost altruistic self-forgetfulness of a battle. There is the break-neck skurry, the flying across the ground and through the air at the risk of limbs and life, and at the mercy of one's own and one's horse's pluck, skill and good fellowship. All this makes up a rapture in which many ugly things vanish, and certain cosmic intuitions flash forth for some, at least, of the hunters. The element of poetry is greater, the element of brutality less, in this form of intoxication than in many others. It has a handsomer bearing than its modern successor, the motor-intoxication, with its passiveness and (for all but the driver) its lack of skill, its confinement, moreover, to beaten roads, and its petrol-stench and dustcloud of privilege and of inconvenience to others. And the intoxication of hunting is, to my thinking at least, cleaner, wholesomer, than the intoxication of, let us say, certain ways of hearing music. But just because so much can be said, both positive and negative, in its favour, I am glad that hunting, and not some meaner or some less seemly amusement, should have set me off moralising about such pleasures as are wasteful of other things or of some portion of our soul.

III

FOR NOTHING CAN BE FURTHER from scientific fact than that cross-grained and ill-tempered puritanism identifying pleasure with something akin to sinfulness. Philosophically considered, Pain is so far stronger a determinant than Pleasure, that its *vis a tergo* might have sufficed to ensure the survival of the race, without the far milder action of Pleasure being necessary at all; so that the very existence of Pleasure would lead us to infer that, besides its function of selecting, like Pain, among life's possibilities, it has the function of actually replenishing the vital powers, and thus making amends, by its healing and invigorating, for the wear and tear, the lessening of life's resources through life's other great Power of Selection, the terror-angel of Pain. This being the case, Pleasure tends, and should tend more and more, to be consistent with itself, to mean a greater chance of its own growth and spreading (as opposed to Pain's dwindling and suicidal nature), and in so far to connect itself with whatsoever facts make for the general good, and to reject, therefore, all cruelty, injustice, rapacity and wastefulness of opportunities and powers.

Nay, paradoxical though such a notion may seem in the face of our past and present state of barbarism, Pleasure, and hence amusement, should become incompatible with, be actually *spoilt by*, any element of loss to self and others, of mischief even to the distant, the future, and of impiety to that principle of Good which is but the summing up of the claims of the unseen and unborn.

IV

I WAS STRUCK, THE OTHER day, by the name of a play on a theatre poster: *A Life of Pleasure*. The expression is so familiar that we hear and employ it without thinking how it has come to be. Yet, when by some accident it comes to be analysed, its meaning startles with an odd revelation. Pleasure, a life of pleasure. . . Other lives, to be livable, must contain more pleasure than pain; and we know, as a fact, that all healthy work is pleasurable to healthy creatures. Intelligent converse with one's friends, study, sympathy, all give pleasure; and art is, in a way, the very type of pleasure. Yet we know that none of all that is meant in the expression: a life of pleasure. A curious thought, and, as it came to me, a terrible one. For that expression is symbolic. It means that, of all

the myriads of creatures who surround us, in the present and past, the vast majority identifies pleasure mainly with such a life; despises, in its speech at least, all other sorts of pleasure, the pleasure of its own honest strivings and affections, taking them for granted, making light thereof.

V

WE ARE MISTAKEN, I THINK, in taxing the generality of people with indifference to ideals, with lack of ideas directing their lives. Few lives are really lawless or kept in check only by the *secular arm*, the judge or policeman. Nor is conformity to *what others do, what is fit for one's class* or *seemly in one's position* a result of mere unreasoning imitation or of the fear of being boycotted. The potency of such considerations is largely that of summing up certain rules and defining the permanent tendencies of the individual, or those he would wish to be permanent; in other words, we are in the presence of *ideals of conduct*.

Why else are certain things *those which have to be done*; whence otherwise such expressions as *social duties* and *keeping up one's position*? Why such fortitude under boredom, weariness, constraint; such heroism sometimes in taking blows and snubs, in dancing on with broken heart-strings like the Princess in Ford's play? All this means an ideal, nay, a religion. Yes; people, quite matter-of-fact, worldly people, are perpetually sacrificing to ideals. And what is more, quite superior, virtuous people, religious in the best sense of the word, are apt to have, besides the ostensible and perhaps rather obsolete one of churches and meeting-houses, another cultus, esoteric, unspoken but acted upon, of which the priests and casuists are ladies'-maids and butlers.

Now, if one could only put to profit some of this wasted dutifulness, this useless heroism; if some of the energy put into the ideal progress (as free from self-interest most often as the *accumulating merit* of Kim's Buddhist) called *getting on in the world* could only be applied in *getting the world along*!

VI

AN EMINENT POLITICAL ECONOMIST, TO whom I once confided my aversion for such *butler's and lady's-maid's ideals of life*, admonished me that although useless possessions, unenjoyable luxury, ostentation, and so forth, undoubtedly represented a waste of the world's energies

and resources, they should nevertheless be tolerated, inasmuch as constituting a great incentive to industry. People work, he said, largely that they may be able to waste. If you repress wastefulness you will diminish, by so much, the production of wealth by the wasteful, by the luxurious and the vain. . .

This may be true. Habits of modesty and of sparingness might perhaps deprive the world of as much wealth as they would save. But even supposing this to be true, though the wealth of the world did not immediately gain, there would always be the modesty and sparingness to the good; virtues which, sooner or later, would be bound to make more wealth exist or to make existing wealth *go a longer way*. Appealing to higher motives, to good sense and good feeling and good taste, has the advantage of saving the drawbacks of lower motives, which *are* lower just because they have such drawbacks. You may get a man to do a desirable thing from undesirable motives; but those undesirable motives will induce him, the very next minute, to do some undesirable thing. The wages of good feeling and good taste is the satisfaction thereof. The wages of covetousness and vanity is the grabbing of advantages and the humiliating of neighbours; and these make life poorer, however much bread there may be to eat or money to spend. What are called higher motives are merely those which expand individual life into harmonious connection with the life of all men; what we call lower motives bring us hopelessly back, by a series of vicious circles, to the mere isolated, sterile egos. Sterile, I mean, in the sense that the supply of happiness dwindles instead of increasing.

VII

WASTE OF BETTER POSSIBILITIES, OF higher qualities, of what we call *our soul*. To denounce this is dignified, but it is also easy and most often correspondingly useless. I wish to descend to more prosaic matters, and, as Ruskin did in his day, to denounce the *mere waste of money*. For the wasting of money implies nearly always all those other kinds of wasting. And although there are doubtless pastimes (pastimes promoted, as is our wont, for fear of yet *other* pastimes), which are in themselves unclean or cruel, these are less typically evil, just because they are more obviously so, than the amusements which imply the destruction of wealth, the destruction of part of the earth's resources

and of men's labour and thrift, and incidentally thereon of human leisure and comfort and the world's sweetness.

Do you remember La Bruyère's famous description of the peasants under Louis XIV? "One occasionally meets with certain wild animals, both male and female, scattered over the country; black, livid and parched by the sun, bound to the soil which they scratch and dig up with desperate obstinacy. They have something which sounds like speech, and when they raise themselves up they show a human face. And, as a fact, they are human beings." The *Ancien Régime*, which had reduced them to that, and was to continue reducing them worse and worse for another hundred years by every conceivable tax, tithe, toll, servage, and privilege, did so mainly to pay for amusements. Amusements of the *Roi-Soleil*, with his Versailles and Marly and aqueducts and waterworks, plays and operas; amusements of Louis XV, with his Parc-aux-Cerfs; amusements of Marie-Antoinette, playing the virtuous rustic at Trianon; amusements of new buildings, new equipages, new ribbons and bibbons, new diamonds (including the fatal necklace); amusements of hunting and gambling and love-making; amusements sometimes atrocious, sometimes merely futile, but all of them leaving nothing behind, save the ravaged grass and stench of brimstone of burnt-out fireworks.

Moreover, wasting money implies *getting more*. And the processes by which such wasted money is replaced are, by the very nature of those who do the wasting, rarely, nay, never, otherwise than wasteful in themselves. To put into their pockets or, like Marshall Villeroi ("a-t-on mis de l'or dans mes poches?"), have it put by their valets, to replace what was lost overnight, these proud and often honourable nobles would ante-chamber and cringe for sinecures, pensions, indemnities, privileges, importune and supplicate the King, the King's mistress, pandar or lacquey. And the sinecure, pension, indemnity or privilege was always deducted out of the bread—rye-bread, straw-bread, grass-bread—which those parched, prone human animals described by La Bruyère were extracting "with desperate obstinacy"—out of the ever more sterile and more accursed furrow.

It is convenient to point the moral by reference to those kings and nobles of other centuries, without incurring pursuit for libel, or wounding the feelings of one's own kind and estimable contemporaries. Still, it may be well to add that, odd though it appears, the vicious circle (in both senses of the words) continues to exist; and that, even

in our democratic civilisation, *you cannot waste money without wasting something else in getting more money to replace it*.

Waste, and *lay waste*, even as if your pastime had consisted not in harmless novelty and display, in gentlemanly games or good-humoured sport, but in destruction and devastation for their own sake.

VIII

IT HAS BEEN LAID WASTE, that little valley which, in its delicate and austere loveliness, was rarer and more perfect than any picture or poem. Those oaks, ivy garlanded like Maenads, which guarded the shallow white weirs whence the stream leaps down; those ilexes, whose dark, loose boughs hung over the beryl pools like hair of drinking nymphs; those trees which were indeed the living and divine owners of that secluded place, dryads and oreads older and younger than any mortals,—have now been shamefully stripped, violated and maimed, their shorn-off leafage, already withered, gathered into faggots or trodden into the mud made by woodcutters' feet in the place of violets and tender grasses and wild balm; their flayed bodies, hacked grossly out of shape, and flung into the defiled water until the moment when, the slaughter and dishonour and profanation being complete, the dealers' carts will come cutting up the turf and sprouting reeds, and carry them off to the station or timber-yard. The very stumps and roots will be dragged out for sale; the earthy banks, raw and torn, will fall in, muddying and clogging that pure mountain brook; and the hillside, turning into sliding shale, will dam it into puddles with the refuse from the quarries above. And thus, for less guineas than will buy a new motor or cover an hour of Monte Carlo, a corner of the world's loveliness and peace will be gone as utterly as those chairs and tables and vases and cushions which the harlot in Zola's novel broke, tore, and threw upon the fire for her morning's amusement.

IX

THERE IS IN OUR IMPERFECT life too little of pleasure and too much of play. This means that our activities are largely wasted in pleasureless ways; that, being more tired than we should be, we lose much time in needed rest; moreover, that being, all of us more or less, slaves to the drudgery of need or fashion, we set a positive value on that negative

good called freedom, even as the pause between pain takes, in some cases, the character of pleasure.

There is in all play a sense not merely of freedom from responsibility, from purpose and consecutiveness, a possibility of breaking off, or slackening off, but a sense also of margin, of permitted pause and blank and change; all of which answer to our being on the verge of fatigue or boredom, at the limit of our energy, as is normal in the case of growing children (for growth exhausts), and inevitable in the case of those who work without the renovation of interest in what they are doing.

If you notice people on a holiday, you will see them doing a large amount of "nothing," dawdling, in fact; and "amusements" are, when they are not excitements, that is to say, stimulations to deficient energy, full of such "doing nothing." Think, for instance, of "amusing conversation" with its gaps and skippings, and "amusing" reading with its perpetual chances of inattention.

All this is due to the majority of us being too weak, too badly born and bred, to give full attention except under the constraint of necessary work, or under the lash of some sort of excitement; and as a consequence to our obtaining a sense of real well-being only from the spare energy which accumulates during idleness. Moreover, under our present conditions (as under those of slave-labour) "work" is rarely such as calls forth the effortless, the willing, the pleased attention. Either in kind or length or intensity, work makes a greater demand than can be met by the spontaneous, happy activity of most of us, and thereby diminishes the future chances of such spontaneous activity by making us weaker in body and mind.

Now, so long as work continues to be thus strained or against the grain, play is bound to be either an excitement which leaves us poorer and more tired than before (the fox-hunter, for instance, at the close of the day, or on the off-days), or else play will be mere dawdling, getting out of training, in a measure demoralisation. For demoralisation, in the etymological sense being *debauched*, is the correlative of over-great or over-long effort; both spoil, but the one spoils while diminishing the mischief made by the other.

Art is so much less useful than it should be, because of this bad division of "work" and "play," between which two it finds no place. For Art—and the art we unwittingly practice whenever we take pleasure in nature—is without appeal either to the man who is straining at business and to the man who is dawdling in amusement.

Æsthetic pleasure implies energy during rest and leisureliness during labour. It means making the most of whatever beautiful and noble possibilities may come into our life; nay, it means, in each single soul, *being* for however brief a time, beautiful and noble because one is filled with beauty and nobility.

X

To EAT HIS BREAD IN sorrow and the sweat of his face was, we are apt to forget, the first sign of man's loss of innocence. And having learned that we must reverse the myth in order to see its meaning (since innocence is not at the beginning, but rather at the end of the story of mankind), we might accept it as part of whatever religion we may have, that the evil of our world is exactly commensurate with the hardship of useful tasks and the wastefulness and destructiveness of pleasures and diversions. Evil and also folly and inefficiency, for each of these implies the existence of much work badly done, of much work to no purpose, of a majority of men so weak and dull as to be excluded from choice and from leisure, and a minority of men so weak and dull as to use choice and leisure mainly for mischief. To reverse this original sinful constitution of the world is the sole real meaning of progress. And the only reason for wishing inventions to be perfected, wealth to increase, freedom to be attained, and, indeed, the life of the race to be continued at all, lies in the belief that such continued movement must bring about a gradual diminution of pleasureless work and wasteful play. Meanwhile, in the wretched past and present, the only aristocracy really existing has been that of the privileged creatures whose qualities and circumstances must have been such that, whether artisans or artists, tillers of the ground or seekers after truth, poets, philosophers, or mothers and nurses, their work has been their pleasure. This means *love*; and love means fruitfulness.

XI

THERE ARE MOMENTS WHEN, CATCHING a glimpse of the frightful weight of care and pain with which mankind is laden, I am oppressed by the thought that all improvement must come solely through the continued selfish shifting of that burden from side to side, from shoulder to shoulder; through the violent or cunning destruction of some of the

intolerable effects of selfishness in the past by selfishness in the present and the future. And that in the midst of this terrible but salutary scuffle for ease and security, the ideals of those who are privileged enough to have any, may be not much more useful than the fly on the axle-tree.

It may be, it doubtless is so nowadays, although none of us can tell to what extent.

But even if it be so, let us who have strength and leisure for preference and ideals prepare ourselves to fit, at least to acquiesce, in the changes we are unable to bring about. Do not let us seek our pleasure in things which we condemn, or remain attached to those which are ours only through the imperfect arrangements which we deplore. We are, of course, all tied tight in the meshes of our often worthless and cruel civilisation, even as the saints felt themselves caught in the meshes of bodily life. But even as they, in their day, fixed their hopes on the life disembodied, so let us, in our turn, prepare our souls for that gradual coming of justice on earth which we shall never witness, by forestalling its results in our valuations and our wishes.

XII

THE OTHER EVENING, SKIRTING THE Links, we came upon a field, where, among the brown and green nobbly grass, was gathered a sort of parliament of creatures: rooks on the fences, seagulls and peewits wheeling overhead, plovers strutting and wagging their tails; and, undisturbed by the white darting of rabbits, a covey of young partridges, hopping leisurely in compact mass.

Is it because we see of these creatures only their harmlessness to us, but not the slaughter and starving out of each other; or is it because of their closer relation to simple and beautiful things, to nature; or is it merely because they are *not human beings*—who shall tell? but, for whatever reason, such a sight does certainly bring up in us a sense, however fleeting, of simplicity, *mansuetude* (I like the charming mediæval word), of the kinship of harmlessness.

I was thinking this while wading up the grass this morning to the craig behind the house, the fields of unripe corn a-shimmer and a-shiver in the light, bright wind; the sea and distant sky so merged in delicate white mists that a ship, at first sight, seemed a bird poised in the air. And, higher up, among the ragwort and tall thistles, I found in the coarse grass a dead baby-rabbit, shot and not killed at once, perhaps;

or shot and not picked up, as not worth taking: a little soft, smooth, feathery young handful, laid out very decently, as human beings have to be laid out by one another, in death.

It brought to my mind a passage where Thoreau, who understood such matters, says, that although the love of nature may be fostered by sport, such love, when once consummate, will make nature's lover little by little shrink from slaughter, and hanker after a diet wherein slaughter is unnecessary.

It is sad, not for the beasts but for our souls, that, since we must kill beasts for food (though may not science teach a cleaner, more human diet?) or to prevent their eating us out of house and home, it is sad that we should choose to make of this necessity (which ought to be, like all our baser needs, a matter if not of shame at least of decorum) that we should make of this ugly necessity an opportunity for amusement. It is sad that nowadays, when creatures, wild and tame, are bred for killing, the usual way in which man is brought in contact with the creatures of the fields and woods and streams (such man, I mean, as thinks, feels or is expected to) should be by slaughtering them.

Surely it might be more akin to our human souls, to gentleness of bringing up, Christianity of belief and chivalry of all kinds, to be, rather than a hunter, a shepherd. Yet the shepherd is the lout in our idle times; the shepherd, and the tiller of the soil; and alas, the naturalist, again, is apt to be the *muff*.

But may the time not come when, apart from every man having to do some useful thing, something perchance like tending flocks, tilling the ground, mowing and forestering—the mere love of beauty, the desire for peace and harmony, the craving for renewal by communion with the life outside our own, will lead men, without dogs or guns or rods, into the woods, the fields, to the river-banks, as to some ancient palace full of frescoes, as to some silent church, with solemn rites and liturgy?

XIII

THE KILLING OF CREATURES FOR sport seems a necessity nowadays. There is more than mere bodily vigour to be got by occasional interludes of outdoor life, early hours, discomfort and absorption in the ways of birds and beasts; there is actual spiritual renovation. The mere reading

about such things, in Tolstoi's *Cossacks* and certain chapters of *Anna Karenina* makes one realise the poetry attached to them; and we all of us know that the genuine sportsman, the man of gun and rod and daybreak and solitude, has often a curious halo of purity about him; contact with natural things and unfamiliarity with the sordidness of so much human life and endeavour, amounting to a kind of consecration. A man of this stamp once told me that no emotion in his life had ever equalled that of his first woodcock.

You cannot have such open-air life, such clean and poetic emotion without killing. Men are men; they will not get up at cock-crow for the sake of a mere walk, or sleep in the woods for the sake of the wood's noises: they must have an object; and what object is there except killing beasts or birds or fish? Men have to be sportsmen because they can't all be either naturalists or poets. Killing animals (and, some persons would add, killing other men) is necessary to keep man manly. And where men are no longer manly they become cruel, not for the sake of sport or war, but for their lusts and for cruelty's own sake. And that seems to settle the question.

XIV

BUT THE QUESTION IS NOT really settled. It is merely settled for the present, but not for the future. It is surely a sign of our weakness and barbarism that we cannot imagine tomorrow as better than today, and that, for all our vaunted temporal progress and hypocritical talk of duty, we are yet unable to think and to feel in terms of improvement and change; but let our habits, like the vilest vested interests, oppose a veto to the hope and wish for better things.

To realise that *what is* does not mean what *will be*, constitutes, methinks, the real spirituality of us poor human creatures, allowing our judgments and aspirations to pass beyond our short and hidebound life, to live on in the future, and help to make that *yonside of our mortality*, which some of us attempt to satisfy with theosophic reincarnation and planchette messages!

But such spirituality, whose "it shall"—or "it shall not"—will become an ever larger part of all *it is*, depends upon the courage of recognising that much of what the past forces us to accept is not good enough for the future; recognising that, odious as this may seem to our self-conceit and sloth, many of the things we do and like and are, will

not bear even our own uncritical scrutiny. Above all, that the lesser evil which we prefer to the greater is an evil for all that, and requires riddance.

Much of the world's big mischief is due to the avoidance of a bigger one. For instance, all this naïvely insisted on masculine inability to obtain the poet's or naturalist's joys without shooting a bird or hooking a fish, this inability to love wild life, early hours and wholesome fatigue unless accompanied by a waste of life and of money; in short, all this incapacity *for being manly without being destructive*, is largely due among us Anglo-Saxons to the bringing up of boys as mere playground dunces, for fear (as we are told by parents and schoolmasters) that the future citizens of England should take to evil communications and worse manners if they did not play and talk cricket and football at every available moment. For what can you expect but that manly innocence which has been preserved at the expense of every higher taste should grow up into manly virtue unable to maintain itself save by hunting and fishing, shooting and horse-racing; expensive amusements requiring, in their turn, a further sacrifice of all capacities for innocent, noble and inexpensive interests, in the absorbing, sometimes stultifying, often debasing processes of making money?

The same complacency towards waste and mischief for the sake of moral advantages may be studied in the case also of our womankind. The absorption in their *toilettes* guards them from many dangers to family sanctity. And from how much cruel gossip is not society saved by the prevalent passion for bridge!

So at least moralists, who are usually the most complacently demoralised of elderly cynics, are ready to assure us.

XV

"We should learn to have noble desires," wrote Schiller, "in order to have no need for sublime resolutions." And morality might almost take care of itself, if people knew the strong and exquisite pleasures to be found, like the aromatic ragwort growing on every wall and stone-heap in the south, everywhere in the course of everyday life. But alas! the openness to cheap and simple pleasures means the fine training of fine faculties; and mankind asks for the expensive and far-fetched and unwholesome pleasures, because it is itself of poor and cheap material and of wholesale scamped manufacture.

VERNON LEE

XVI

Biological facts, as well as our observation of our own self (which is psychology), lead us to believe that, as I have mentioned before, Pleasure fulfils the function not merely of leading us along livable ways, but also of creating a surplus of vitality. Itself an almost unnecessary boon (since Pain is sufficient to regulate our choice), Pleasure would thus tend to ever fresh and, if I may use the word, gratuitous supplies of good. Does not this give to Pleasure a certain freedom, a humane character wholly different from the awful, unappeasable tyranny of Pain? For let us be sincere. Pain, and all the cruel alternatives bidding us obey or die, are scarcely things with which our poor ideals, our good feeling and good taste, have much chance of profitable discussion. There is in all human life a side akin to that of the beast; the beast hunted, tracked, starved, killing and killed for food; the side alluded to under decent formulæ like "pressure of population," "diminishing returns," "competition," and so forth. Not but this side of life also tends towards good, but the means by which it does so, nature's atrocious surgery, are evil, although one cannot deny that it is the very nature of Pain to diminish its own recurrence. This thought may bring some comfort in the awful earnestness of existence, this thought that in its cruel fashion, the universe is weeding out cruel facts. But to pretend that we can habitually exercise much moral good taste, be of delicate forethought, squeamish harmony when Pain has yoked and is driving us, is surely a bad bit of hypocrisy, of which those who are being starved or trampled or tortured into acquiescence may reasonably bid us be ashamed. Indeed, stoicism, particularly in its discourses to others, has not more sense of shame than sense of humour.

But since our power of choosing is thus jeopardised by the presence of Pain, it would the more behove us to express our wish for goodness, our sense of close connection, wide and complex harmony with the happiness of others, in those moments of respite and liberty which we call happiness, and particularly in those freely chosen concerns which we call play.

Alas, we cannot help ourselves from becoming unimaginative, unsympathising, destructive and brutish when we are hard pressed by agony or by fear. Therefore, let such of us as have stuff for finer things, seize some of our only opportunities, and seek to become harmless in our pleasures.

Who knows but that the highest practical self-cultivation would not be compassed by a much humbler paraphrase of Schiller's advice: let us learn to like what does no harm to the present or the future, in order not to throw away heroic efforts or sentimental intentions, in doing what we don't like for someone else's supposed benefit.

XVII

THE VARIOUS THINGS I HAVE been saying have been said, or, better still, taken for granted, by Wordsworth, Keats, Browning, Ruskin, Pater, Stevenson, by all our poets in verse and prose. What I wish to add is that, being a poet, seeing and feeling like a poet, means quite miraculously multiplying life's resources for oneself and others; in fact the highest practicality conceivable, the real transmutation of brass into gold. Now what we all waste, more even than money, land, time and labour, more than we waste the efforts and rewards of other folk, and the chances of enjoyment of unborn generations (and half of our so-called practicality is nothing but such waste), what we waste in short more than anything else, is our own and our children's inborn capacity to see and feel as poets do, and make much joy out of little material.

XVIII

THERE IS NO MACHINE REFUSE, cinder, husk, paring or rejected material of any kind which modern ingenuity cannot turn to profit, making useful and pleasant goods out of such rubbish as we would willingly, at first sight, shoot out of the universe into chaos. Every material thing can be turned, it would seem, into new textures, clean metal, manure, fuel or what not. But while we are thus economical with our dust-heaps, what horrid wastefulness goes on with our sensations, impressions, memories, emotions, with our souls and all the things that minister to their delight!

XIX

AN IGNORANT FOREIGN BODY—AND, after all, everyone is a foreigner somewhere and ignorant about something—once committed the enormity of asking his host, just back from cub-hunting, whether the hedgerows, when he went out of a morning, were not quite lovely

with those dewy cobwebs which the French call Veils of the Virgin. It had to be explained that such a sight was the most unwelcome you could imagine, since it was a sure sign there would be no scent. The poor foreigner was duly crestfallen, as happens whenever one has nearly spoilt a friend's property through some piece of blundering.

But the blunder struck me as oddly symbolical. Are we not most of us pursuing for our pleasure, though sometimes at risk of our necks, a fox of some kind: worth nothing as meat, little as fur, good only to gallop after, and whose unclean scent is incompatible with those sparkling gossamers flung, for everyone's delight, over gorse and hedgerow?

THE END

A Note About the Author

Vernon Lee (1856–1935) was the pen name of Violet Paget, a British author of supernatural fiction. Born in France to British expatriate parents, Paget spent most of her life in continental Europe. A committed feminist and pacifist, she joined the Union of Democratic Control during the First World War to express her opposition to British militarism. A lesbian, Paget had relationships with Mary Robinson, Amy Levy, and Clementina Anstruther-Thomson throughout her life. Paget, a dedicated follower of Walter Pater's Aesthetic movement, lived for many years in Florence, where she gained a reputation as a leading scholar of the Italian Renaissance. In addition to her work in art history, Paget was a leading writer of short fiction featuring supernatural figures and themes. Among her best known works are *Hauntings* (1890), a collection of four chilling tales, and "Prince Alberic and the Snake Lady," a story which appeared in an 1895 issue of *The Yellow Book*, a controversial periodical that featured the works of Aubrey Beardsley, George Gissing, Henry James, and William Butler Yeats. Although Paget was largely forgotten by the mid-twentieth century, feminist scholars have rekindled attention in her pioneering work as a leading proponent of Aestheticism.

A Note from the Publisher

Spanning many genres, from non-fiction essays to literature classics to children's books and lyric poetry, Mint Edition books showcase the master works of our time in a modern new package. The text is freshly typeset, is clean and easy to read, and features a new note about the author in each volume. Many books also include exclusive new introductory material. Every book boasts a striking new cover, which makes it as appropriate for collecting as it is for gift giving. Mint Edition books are only printed when a reader orders them, so natural resources are not wasted. We're proud that our books are never manufactured in excess and exist only in the exact quantity they need to be read and enjoyed.

Discover more of your favorite classics with Bookfinity™.

- Track your reading with custom book lists.
- Get great book recommendations for your personalized Reader Type.
- Add reviews for your favorite books.
- AND MUCH MORE!

Visit **bookfinity.com** and take the fun Reader Type quiz to get started.

Enjoy our classic and modern companion pairings!

Bookfinity is a registered trademark of Ingram Book Group LLC. © 2023 Bookfinity. All rights reserved.

Printed in the USA
CPSIA information can be obtained
at www.ICGtesting.com
JSHW082352140824
68134JS00020B/2036

9 781513 295688